CONTEMPORARY PUBLIC ART IN CHINA

CONTEMPORARY PUBLIC ART IN CHINA

A Photographic Tour

JOHN T. YOUNG

A Samuel and Althea Stroum Book

UNIVERSITY OF WASHINGTON PRESS

Seattle and London

This book is published with the assistance of a grant from the Stroum Book Fund, established through the generosity of Samuel and Althea Stroum.

All photographs are by John T. Young unless noted otherwise.

Illustration facing title page from *Seduction Series* by Zhan Wang (see p. 44)

Library of Congress Cataloging-in-Publication Data

Young, John T.
 Contemporary public art in China : a photographic tour / John T. Young.
 p. cm.
 "A Samuel and Althea Stroum book"
 Includes index.
 ISBN 0-295-97708-6 (alk. paper)
 1. Public art—China. 2. Art, Chinese—20th century. 3. Public art—
 China—Pictorial works. 4. Art, Chinese—20th century—Pictorial works.
 I. Title.
N8846.C6Y68 1998
709'.51'09045—dc21 97-47141
 CIP

Contents

Preface

This book is based on a journey I made in 1995 to a land and culture that makes public art in a very different way from that of my own culture. China was isolated from the Western world for many years and, like the continent of Australia, which developed unique animal species through the course of evolution, China has evolved its own directions in public art during the past fifty years.

My journey was made all the more exciting because the art of China, like all of Chinese society and culture, is in the throes of dramatic change. The West has experienced a taste of this change since the "gates of China" opened in the 1980s. Galleries and museums around the world have begun exhibiting works by contemporary Chinese artists, mostly painters, that shed light on a culture that is unique, dynamic, and full of contrasts. China is a "developing nation," yet it has existed for over five thousand years; it is a society of tremendous poverty, yet it manufactures much of the world's goods and is rapidly embracing technology; it is controlled by an authoritarian, communist government, yet it also functions as a free-market economy reminiscent of the boomtown era of the California gold rush. Such contrasts, and the anxieties they produce, provide grist for the provocative art that is coming out of China today.

But what of China's public art—the statues and monuments sited in plazas, squares, and traffic circles? What does the art look like when it is locked into its site and is created and commissioned to

represent the interests of the public? Who determines the subject matter of these monuments, and how much freedom of expression do the artists have in interpreting these themes? These were some of the questions I wished to ask Chinese public artists and art administrators when I applied to the University of Washington Royalty Research Fund Grant Committee for research support.

In 1991 I first met Yuan Yunfu, one of China's foremost public artists and muralists, who, like many of his colleagues, has grown children studying or permanently living in the United States whom he occasionally visits. He and I delivered a joint lecture at the University of Washington's School of Architecture titled "To Confront or Confirm," in which we explored the premise that Chinese public art generally tends to confirm the cultural values of Chinese society, while American public art tends to confront cultural values. It was Yuan Yunfu and this lecture that inspired me to visit China and undertake this project.

With the support of the Royalty Research Fund, I spent several months in the People's Republic of China in the spring of 1995, accompanied by my Chinese-born graduate research assistant, Wu Haiying. We visited more than thirty cities and traveled several thousand miles, documenting public art and interviewing artists whose ages ranged from twenty-three to over seventy-three. The resulting collection of photographs includes 2,500 slides taken with Nikon lenses and six hundred medium-format transparencies taken with a Hasselblad 501-C. Since I am a practicing professional sculptor and public artist as well as a university professor specializing in contemporary sculpture and public art, artists in China welcomed me as a "brother" and provided me with extraordinary access and insights into public art, especially sculpture.

The sheer quantity of public works in China—more than ten thousand created since 1949, most of them commissioned since 1980—attests to their importance to Chinese society, as does the amount of money spent on each project. I saw many artworks that

were as large as an American football field and cost the government in excess of the equivalent of US$1 million. The cover photo (discussed in the Xi'an section) illustrates one of these monumental works.

What follows is a selection of an American sculptor's photographs of public art in China. I have not attempted a critical or historical analysis of the public art of China; but I hope this sample of the vast body of public artworks may provide a starting point for art historians who are interested in these aspects of Chinese art. This volume is intended for anyone who is intrigued by public art, by the art of China, and by the process through which it has been created, as expressed by the practitioners themselves, my Chinese colleagues.

Acknowledgments

This book would not have been possible without the generous support of many people on two continents. The entire project was funded by a grant from the University of Washington Royalty Research Fund, which was created by pooling research-generated royalties given to the University by professors who have created significant inventions, patents, and discoveries. The bulk of this funding pool comes from a single source, botany and genetics professor Ben Hall, who helped discover the most effective test and vaccination for hepatitis, a disease that, ironically, afflicts a vast population in China.

In the planning stages of this expedition, two of my close colleagues at the University were extremely generous with their insights and advice regarding travel in China: Jerome Silbergeld, Chinese art historian; and Bill Lavely, sociologist and member of the Jackson School of International Studies. Bill's research into female infanticide practices has taken him into remote regions in Yunnan Province, and his advice on traveling and staying healthy and safe in China was most useful. Joe Norman, former vice provost for International Education, has been extremely supportive of efforts to establish at the University of Washington the first-ever exchange program among public artists of China and the United States. Two Chinese-born students provided invaluable translation skills: Zhang Meng, a University of Washington art major and daughter of the director of the Yunnan Arts Academy in Kunming; and Hong Cheng,

a Harvard Medical School student and daughter of the famous Beijing sculptor Cheng Yunxian, who is featured prominently in this book. Communication with Cheng Yunxian in Beijing by e-mail via Hong Cheng in Massachusetts was rapid and efficient, and represented the beginning of a new and exciting way to do research with Chinese colleagues. Thanks also go to Linda Moran from the School of Art, who made sure that accounting for the grant was always in order, a task made challenging since the thousands of receipts were always in Chinese!

All of the Chinese artists and art administrators mentioned in this text were extremely gracious with their time, in many cases spending days with us at the expense of their usual work load and their private lives. My deepest gratitude extends out to them and I hope that these efforts benefit them in some tangible way. Others who generously assisted us were Zhu Guorong and Zheng Jiashi of the Shanghai Public Art Office; Feng Yiming of the Nanjing Academy of Art; Wuhan artist Cheng Yuchung; Pan He's son Pan Le, who drove us all over southeast China; and Wang Zhangpei and her son Wang Zhan, who spent several days with us in the region around Xi'an. Space does not permit the inclusion of all of the fine public artists practicing in China today and all of the other wonderful people we met, but these artists and friends provided us with tremendous insights into their work and their lives. As a result, I have accepted the joyful responsibility of being their messenger, exposing their works to the Western world. I apologize to them, in advance, for any errors or omissions that may have been made in translation, fact finding, and the writing of this text.

My new friend Cao Chunsheng, sculptor and professor at the Central Fine Arts Academy in Beijing, deserves special thanks for being such a terrific host to my family and me, for arranging lecture opportunities for me at the major arts institutions in Beijing, for his enthusiasm in exploring the possibilities of international exchange between our institutions, and for always doing so with

good cheer and unflappable gusto. Cao gave us valuable background information, great suggestions for route planning, and a superb launch for our nationwide tour.

I am grateful to Cheng Yunxian, renowned portrait sculptor and director of research for the art of sculpture at the People's Liberation Army Military Museum, and Cao for meeting us at our hotel in Beijing on our first day in China. With their support of our project, word got around the entire country and amazing doors opened to us that we had believed were closed.

Ye Yushan, former director of the renowned Sichuan Fine Arts Academy and now Peoples' Representative to the central government from Sichuan Province, was our generous host in central China. A handsome, sophisticated man in his early sixties, Ye showed us his own works and those of younger artists from his region. He was often accompanied by his charming friend Chong Hua, who generously toured us around Chongqing in her Mercedes during the few times Ye was unable to be with us. Ye and I became such good friends that we are presently developing ideas for artworks to be placed or exhibited in both of our countries. Our first completed collaborative work was exhibited in September 1996 at the O. K. Harris Gallery in New York City. Seattle will soon be the proud owner of one of Ye's outdoor sculptures.

Wu Haiying assisted me throughout the project on both continents. Wu, born and raised in Chengdu, received his undergraduate training in sculpture at the Sichuan Fine Arts Academy and collaborated on several large-scale public projects in Sichuan. Following the student demonstrations in China in 1989, he immigrated to the United States, where he began a career as a public sculptor in Washington State. In 1994, as a graduate student in the University of Washington Sculpture Program, he assisted me in making the arrangements for this expedition. His knowledge of all of the artists practicing public art was indispensable in planning our journey, and he wrote numerous letters to them preparing for our arrival. In

China he served as translator and guide and got us around without incident in regions where travel can be notoriously difficult. One of the most amusing challenges he faced during our two-month odyssey together was translating during our numerous luncheon interviews with artists. As translator, he was always speaking, either in Chinese or English, consequently never having time to eat his own lunch! Upon our arrival home, he checked and retranslated many hours of audiotaped interviews and helped catalog thousands of photographs. Without him this project could not have happened, and I am extremely grateful for his participation and his tremendous contributions.

I am grateful to Madeleine Dong, professor of international studies at the University of Washington, and to Kristen Stapleton, assistant professor of history at the University of Kentucky, for their historical research regarding works in Chengdu. Special thanks go to Naomi Pascal, associate director and editor-in-chief of the University of Washington Press, who believed in this project from the very beginning and who has managed to turn the musings of a visual artist into something verbally comprehensible; and to editor Lorri Hagman, for her superb book planning and editing. Her interest in China, familiarity with the Chinese language, and exacting use of English proved to be of extraordinary value. Thanks also to Bob Hutchins for his excellent design and layout of the book, and to my sister-in-law, Maria Young, for her superb job in indexing.

And finally, I must thank my wife, Winnie, who single-handedly cared for our children while I was away from home for months and who has always supported my ideas and ambitions in art and research. I have long realized that she is my greatest treasure of all.

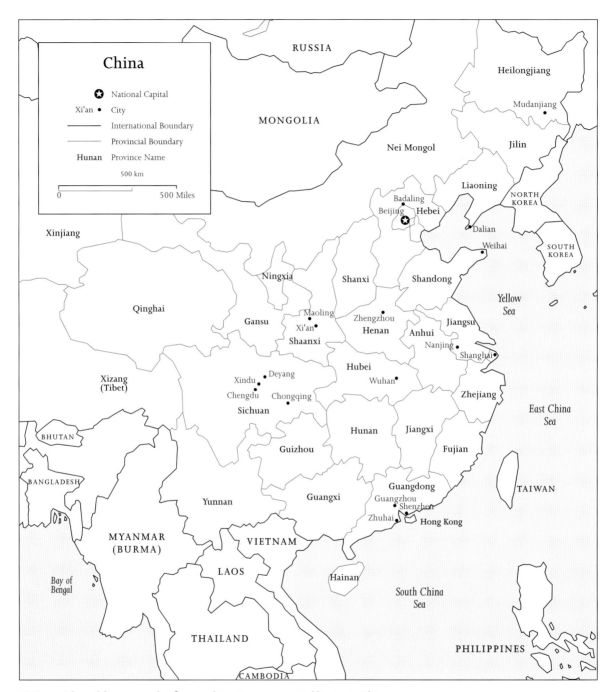

Cities with public artworks featured in *Contemporary Public Art in China*

CONTEMPORARY
PUBLIC ART
IN CHINA

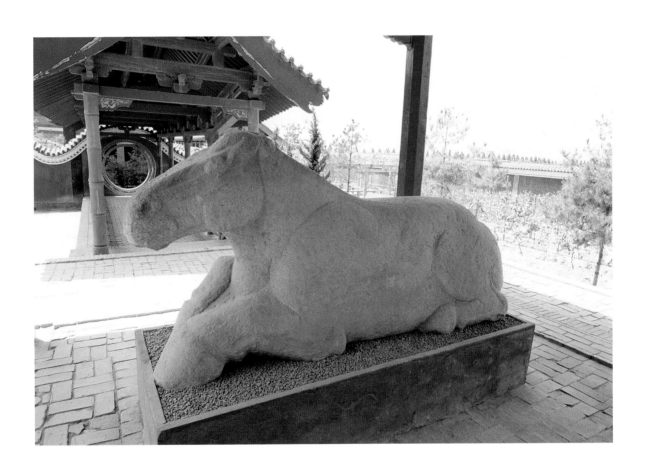

2

Tradition

Horse. *Anonymous. Stone, commemorating General He Qubing; Han dynasty,*
1 B.C.E.*; Maoling*

Following the demise of the Cultural Revolution in 1976, contemporary artists have regained the freedom to look back at their roots in China's long tradition of public sculpture. The carvings from this ancient tomb have inspired many sculptors across the nation.

Several of the artists I interviewed shared their views of the development of contemporary Chinese sculpture. Zhang Yonghao, renowned sculptor and director of the Public Art Office of the City of Shanghai, discussed the history of Chinese public art: "We can trace the history of sculpture in China back two thousand years. The sculpture from this period is characterized by its simplicity of form and avoidance of excessive detail. The object was to portray the spirit of the figure or animal with as little detail as possible. The best historical examples of this can be seen at He Qubing's tomb. The statues there use the natural form of the rock as the basis for capturing the essence of the animals portrayed. You can also see this type of simplicity in the terra-cotta warriors in Xi'an [from 3rd cent. B.C.E.]."

Beijing

Mao Zedong. *Various artists. Painted portrait; 1989; Tiananmen Square, Beijing*

This large portrait of the late Chairman Mao hangs on an outside building wall on the edge of Tiananmen Square. Because it is exposed to the weather, it is repainted regularly by various artists.

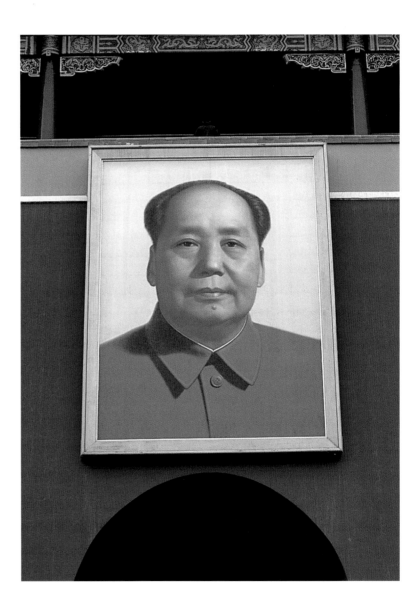

Mao Zedong. *Ye Yushan, Zhang Songhe, Wang Keqing, Cao Chunsheng, Bai Lansheng, Sun Jiabin; tapestry behind the statue by Huang Yongyu. Marble carving; 1978; Chairman Mao Memorial Hall, Tiananmen Square, Beijing*

This photograph was taken after thousands of tourists had left this popular attraction. A soldier, my assistant, one of the six sculptors who had worked on the statue, and I were alone after-hours in the massive building with the statue and Mao's body. The tungsten lights, usually reserved for visits by heads of state, were turned up for this rare photograph of the statue and the tapestry behind it, unobstructed by visitors. I was able to interview three of the artists.

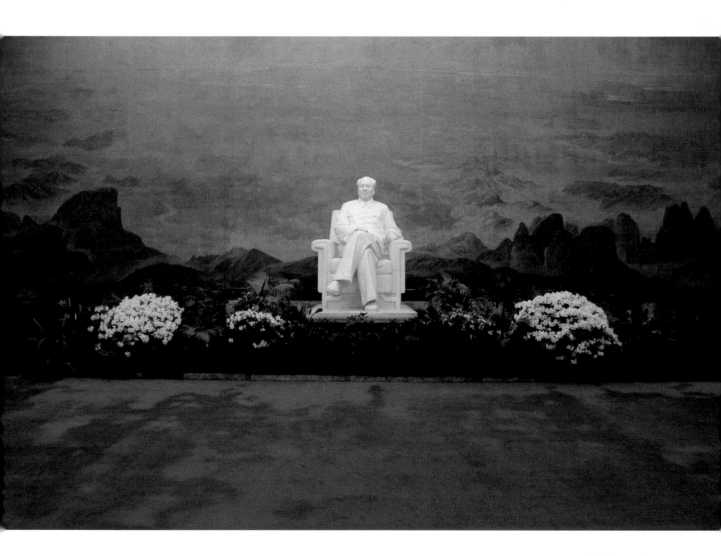

Their sharing of information on process and aesthetics, accompanied by frank talk about levels of freedom of expression, was characteristic of my entire journey, and their comments and photos of their works are found throughout this book.

Chinese-art historian Jerome Silbergeld, of the University of Washington, provided insight into the huge tapestry behind the Mao sculpture: "It was designed by Huang Yongyu, a former printmaking professor, now in his seventies, from the Central Fine Arts Academy. A diverse artist and controversial figure, in political trouble with the authorities in 1959 and then throughout the Cultural Revolution [1966–76], when he was publicly beaten by Red Guards and sent to work among peasants for years, Huang was not the likely candidate to have designed a work of such national importance, coming so quickly on the heels of his political rehabilitation. He produced a ninety-foot-long design on which the landscape tapestry was based. When credits were published for the many artists involved in helping design the Mao Memorial Hall, however, Huang's name was suppressed and his design drawings have never been displayed or published. Viewing the sculpture as primary and the tapestry as a backdrop in a skillfully paired display, one can see the vast panorama of mountains, rivers, and lofty waterfalls as referring to the landscape's spiritual resonance and its enormous dignity to the deceased Chairman Mao and to the Chinese people."

Since the 1949 revolution, traditional figurative portraiture—usually of leaders, heroes, political intellectuals, and artists or poets well known to the public—has prevailed in Chinese public art. These are generally well-executed figures or busts done by highly trained sculptors. Among the very best of these artists are several who are based in Beijing and affiliated with the Central Fine Arts Academy. Among these are Cao Chunsheng, director of the sculpture program; Situ Zhaoguang, a professor; and Wang Keqing, chairman of the National Guidance Committee for the Construction

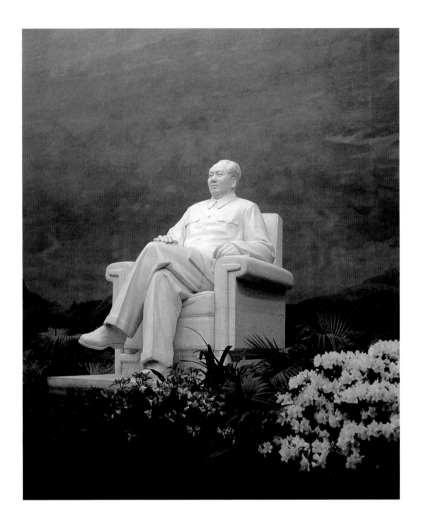

of Urban Sculptures. These are gentlemen in their sixties, trained by professors who had studied the figure in France and Italy in the 1930s and 1940s, before the doors of China closed for thirty years. All have worked on some of the most significant portrait commissions in the country, and their works are characterized by an excellent sense of physical accuracy, accompanied by sensitivity and a poetic rendition of the subject's personality. They are true masters of this portrait art.

Reading. *Situ Zhaoguang. Marble; c. 1989; Zhenyi Road traffic island, Beijing*

This sculpture, located on a thin traffic-island park between two very busy streets, is integrated with its site in a delightful way: the girl is depicted plugging her ears against the sound of the roaring traffic so that she can concentrate on reading her book.

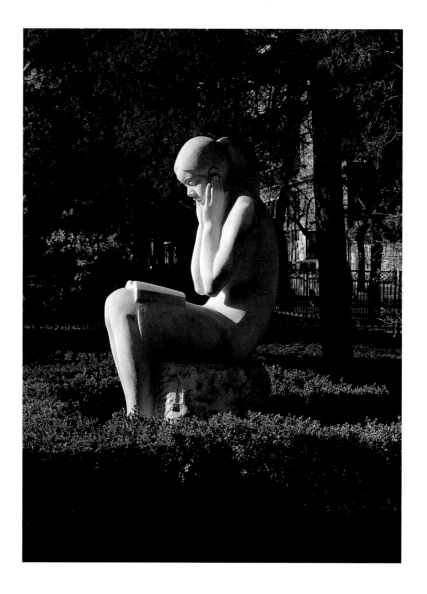

Zither. *Cao Chunsheng. Bronze; c. 1989 Zhenyi Road traffic island, Beijing*

Located immediately opposite the path from Situ's *Reading*, this bronze sculpture depicts a girl of about the same age playing her Chinese zither (qin). The two works together attempt to create a peaceful oasis in an otherwise hectic and noisy setting. Cao and Situ are colleagues in the Sculpture Department at the Central Fine Arts Academy and are close friends, having worked together for over thirty years.

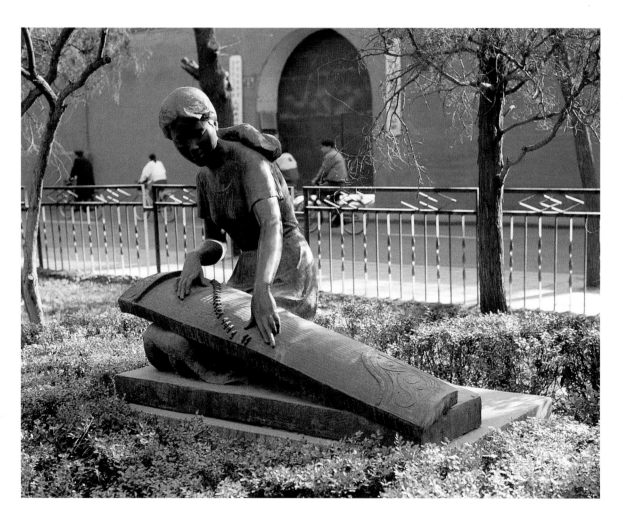

Zhu Ziqing. *Wang Keqing. Marble; Qinghua University, Beijing*

Zhu Ziqing (1898–1948), an essayist and poet, taught Chinese language and literature at Qinghua University. He died of poverty and illness; it is commonly believed that he starved to death as a consequence of refusing to eat American famine-relief flour.

Xiao Luobutou. *Zhang Runkai. Granite carving; 1990; Young Pioneer Park, Beijing*

In Young Pioneer Park more than twenty sculptures depict real and legendary child heroes throughout Chinese history. This one tells the story of Xiao Luobutou, Little Radish Head, whose Communist parents were arrested by the Nationalists in the early 1940s and imprisoned at Gele Mountain, a concentration camp outside

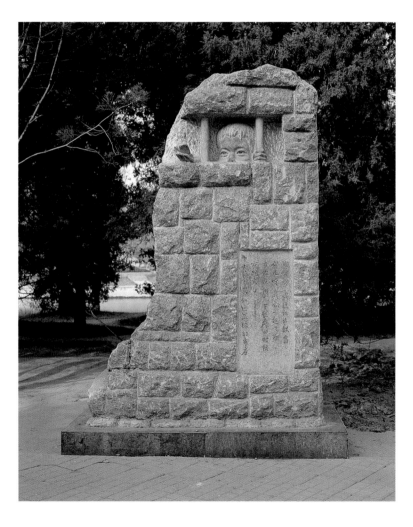

Chongqing created by the Nationalists and American agents to detain Communist revolutionaries. Little Radish Head was born in prison, soon after his parents' incarceration. As he grew up, the prisoners often used him to pass secret notes among themselves, since the little boy was free to run about the prison grounds. One day the seven-year-old boy captured a beautiful butterfly. He was joyfully showing off his live treasure to the adults when an elderly woman said to him, "This butterfly is now imprisoned by you the same way you are imprisoned by these walls. How do you feel about that?" Little Radish Head's release of the butterfly is the instant the sculptor chose to portray. Shortly after this episode, Little Radish Head and his parents were executed by the Nationalists, so this little boy never saw life outside of prison. The task of carving a granite butterfly, an extremely difficult one that most sculptors would avoid, has been accomplished with finesse by Zhang Runkai.

Wen Yiduo. *Qian Shaowu. Granite; Qinghua University, Beijing*

Wen Yiduo (1899–1946), a poet, scholar, and university professor, was assassinated after speaking out against the Nationalist government at a rally in response to the assassination of democratic activist Li Gongpu.

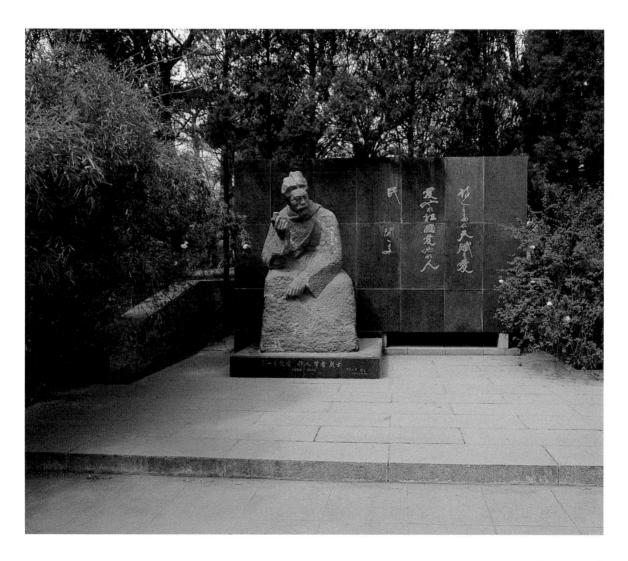

Sima Guang Breaks the Vat. *Zhang Dasheng. Bronze and stone; 1990; Young Pioneer Park, Beijing*

This work tells the story of a young boy, adept at climbing but unable to swim, who slipped into a large, elevated vat of water and began to drown. His playmates panicked when they could not climb up and rescue him, but an intelligent lad named Sima Guang analyzed the situation and broke the vat, thus saving the drowning boy without having to climb up himself. Sima Guang later became a famous scholar and foremost politician of the eleventh century.

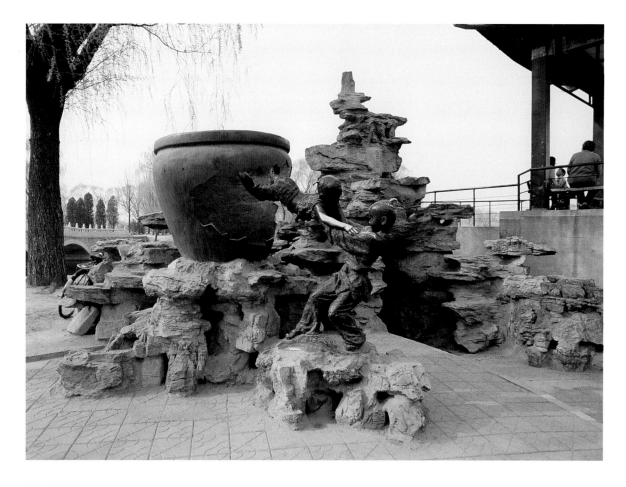

Deng Xiaoping. *Cheng Yunxian.*
Bronze; 1987; National Art Gallery,
Beijing

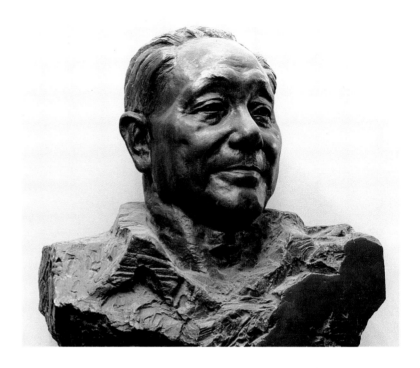

Cheng Yunxian, another Beijing portrait master in his sixties, is one of the most influential public artists presently practicing in China. Cheng is the director of research for the art of sculpture at the People's Liberation Army Military Museum and has created many portraits of contemporary political and military leaders. He is an extremely talented sculptor, whose usually large-scaled works convey the heroic power and accomplishments of the subjects, while also showing their humanity. "My portraits reflect my culture," he told us. "I do portraits of well-known historical figures. Recently I did one of Chairman Mao, Deng Xiaoping, and some generals. All of them made great contributions to the development and progress of New China and are highly respected by the Chinese. I show their demeanor and expression to the people and these statues are left for future generations. This is to commemorate them and also educate the next generation. It's a contribution to society."

Cheng's studio in Beijing, a warehouse-sized structure with thirty-foot ceilings and abundant light, is the largest I saw in China. It is attached to the People's Liberation Army Military Museum, which celebrates China's military successes with full-sized displays of actual weapons and military vehicles. Cheng employs ten full-time assistants, including an accountant and numerous carvers, clay workers, and plaster-mold technicians. He has a car and a personal driver, symbols of great status among artists and government officials. Along the walls of one of the large rooms in his studio were displayed numerous full-scale plasters of works of political and military heroes that were to be cast in bronze, as well as large clay models of works in progress. One of these clay models was twenty-five feet tall and was surrounded by a hoist and scaffolding. In Cheng's office, numerous cases displayed preliminary maquettes that were to be developed into larger commissions. Included in this charming collection of miniature sculptures were some maquettes that had been rejected for full-scale development but gave me insight into the working processes of a Chinese public sculptor, particularly regarding the collaborative nature of much public art. A couple of established younger artists assisted him and worked on their own projects as part of this large operation, including his twenty-five-year-old son, who is rapidly gaining a reputation of his own, and a Chinese artist who resides most of the time in Los Angeles but was working on a commission in China.

Celebration of the Bumper Harvest. *Collaborative work by Luxun Fine Arts Academy professors and students. 1959; National Agriculture Exhibition Hall, Beijing*

This depiction of peasant farmers joyously celebrating a bumper-crop year is an early example of "social realist romanticism"—a term widely used by many of the artists I interviewed, which melds the officially accepted art historical terms "socialist realism" and "revolutionary romanticism."

The pieces composing this work portray anonymous peasants, workers, or soldiers, toiling away on behalf of communism. They are working to their physical limit, but always with a joyful smile, heartened by their belief in their goal. The soldiers are vigorous fighters, ready to sacrifice themselves for the cause. Such works, despite their obviously propagandistic message, convey a powerful sense of community spirit and mission that is a testament to the artists' abilities.

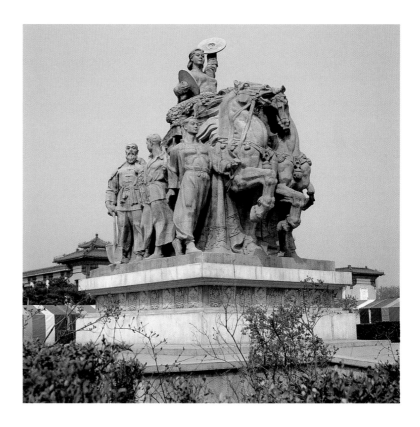

This type of work is uniquely Chinese. Although clearly influenced by the social realist statues of the former Soviet Union, the Chinese versions generally depict subjects in a much more dramatic and theatrical manner. The emotional and spiritual content seems to be more elevated, hence the term "romanticism." Joy and pride in participation in the Party's endeavors, and anger at and defiance of the enemy, are the overt Maoist themes of these works.

Zhang Yonghao explained the development of Chinese social realist romanticism: "Development of our contemporary art is based on European art of the 1920s and 1930s. Sculptors, including myself, were influenced by Western art because our teachers had studied in the European academies, especially in France. They were exchange students at that time, before the doors to China closed shut. They brought back what they learned and practiced. They, along with Western visitors, made some very good works, especially in Shanghai, during that period. Unfortunately, most of those works were destroyed and melted down for the metal.

"Then in the 1950s, after the founding of the People's Republic of China, the Communists respected art and established fine arts academies all over China. These academies included sculpture departments. Since most of the professors of these institutions had studied abroad, they created an education system based on the Western model, which was most familiar to them. This was one of the biggest achievements in Chinese art history—the importation of Western art education into all of China's major cities. We should give credit to the academies that trained the many professionals we have today.

"From the 1950s to the end of the 1970s everything in China was unified, so the art during that period was less about personal aesthetics and more about serving politics. Our political statement was to serve the people. Most of these works were propaganda, but they also contained sensibilities about the life and experiences of the people in our society. It was certainly not as wide open as it is

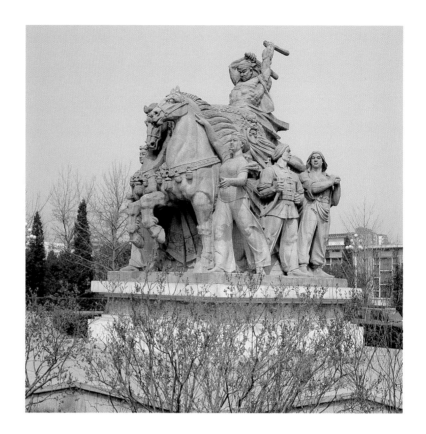

today, however. We artists had our own limitations, too. We believed in the spirit of the time, in the subject matter of peasants, soldiers, hardship, and hard work. We were told by the government what subjects to do, but we were not told how to portray them. This was not a problem, really, because the artists had the same ideas about their subjects as did the Communist officials. Everyone believed Mao was a great figure, and I, as an artist, also believed this. And like artists everywhere else in the world, in Europe or America, artists in China wanted to satisfy their sponsor. I loved what I was doing, and I wanted to do my best to express the inner thoughts and natures of our great leaders and thinkers. But regardless of the political spirit of the times, sculptural art language always praises life in a positive way. Sculpture is the art of praise."

People's Heroes Monument. Liu Kaiqu, Hua Tianyou, Wang Lingyi, Zhang Songhe, Zhang Zhushao, Fu Tianchou, Wang Binzhao, Xiao Chuanjiu. Carved marble relief, 1959; Tiananmen Square, Beijing

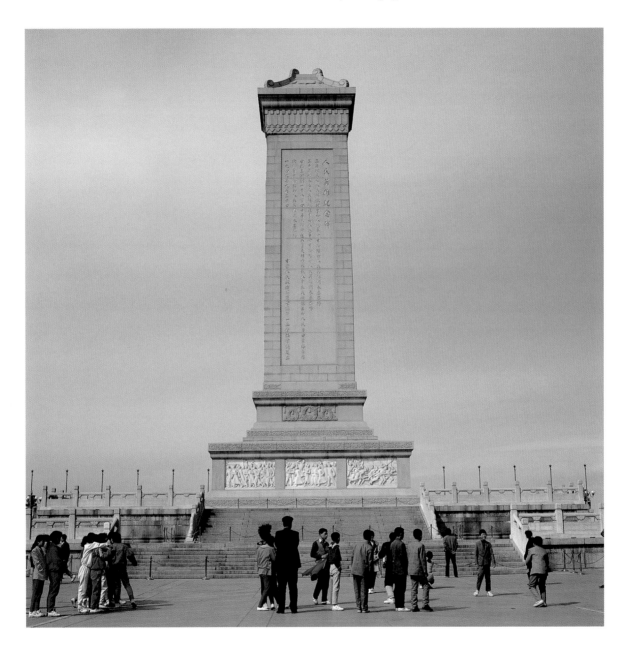

This monument is near the center of Tiananmen Square and stands 118 feet tall. It is a tribute to the heroes of the Chinese Revolution and contains the calligraphy of Mao and Zhou Enlai, along with bas reliefs near its base.

"There have been two big upsurges of activity following the founding of the People's Republic of China," Wang Keqing told us. "After 1949 the government started to build monuments and gathered sculptors from all over the country. A series of large-scale memorial monuments and statues was created, including statues of [the famous early-twentieth-century writer] Lu Xun and [revolutionary leader and founder of the Republic of China] Sun Yatsen. These statues reflect the history of the Chinese people's epic revolutionary struggles against imperialistic and feudalistic forces during the last century and more.

"In 1959, to mark the tenth anniversary of the establishment of the People's Republic, a number of large outdoor sculptures were erected around major buildings constructed at that time, including the Agricultural Exhibition Hall, the Great Hall of the People, the Military Museum, and the *People's Heroes Monument* in Tiananmen Square. In their artistic exploration, Chinese artists carried forward the tradition of ancient Chinese sculptural arts and drew on their experience of realistic arts from Europe. Some of these projects are excellent examples of early social realist romantic works of high quality."

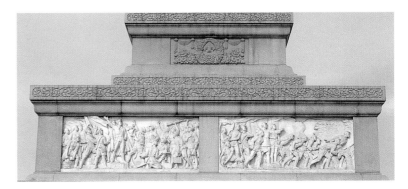

Memorial Hall Group Sculptures. *Collaborative work of 108 artists. Cast concrete; 1978; outside Mao Memorial Hall, Tiananmen Square, Beijing*

All of the large projects sponsored by the government prior to the 1980s involved the collaboration of a number of artists who were assigned to work together designing, creating maquettes, critiquing each other's contributions, and directing the fabrication of the finished product. The third-century-B.C.E. terra-cotta warriors of Xi'an give evidence that collaboration—whether coerced or not—is deeply rooted in Chinese tradition. The largest collaboration in recent times was the creation of the sculptures flanking Mao Memorial Hall in Tiananmen Square, which involved 108 sculptors from all over China. The government built a small village of

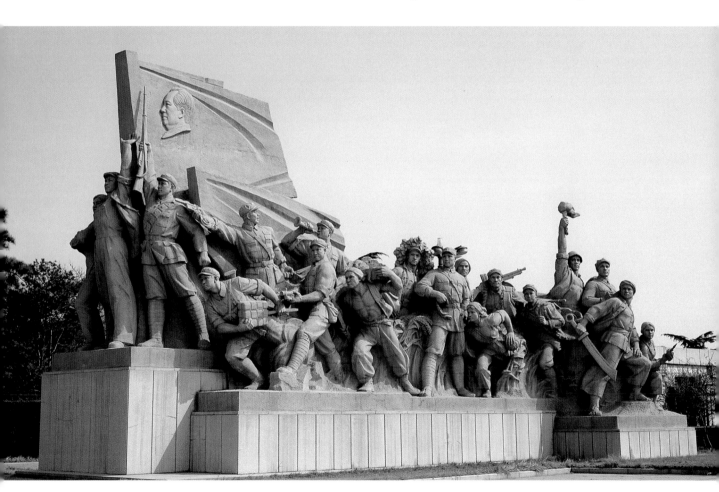

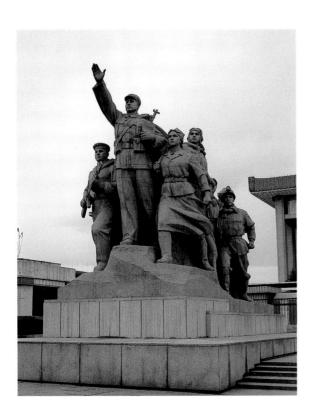
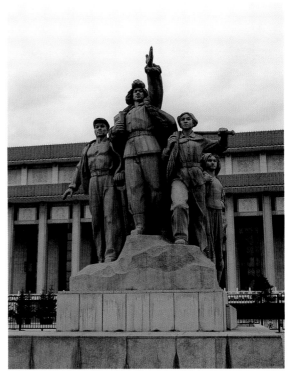

barracks for the artists from outside of Beijing, who lived together like a military troop for the entire length of the project. Artists usually did not sign such collaborative works, and only in recent publications are they even mentioned.

The collaborative spirit appears to have been one of tremendous enthusiasm and cooperation, sometimes resulting in the completion of an enormous project in less than a year. The artists who accomplished these works say they were fueled and inspired by the tenets of the Communist Party. Their reward was the heartfelt belief that they were making a significant contribution to their society, especially by documenting recent history and depicting moral and political ideals. They received no financial compensation, although their participation secured teaching positions in art academies.

Mao Zedong. *Anonymous collaborative work. Stone; 1960s; Sports College, Beijing*

Prior to the "Thought Liberation Conference" in Beijing in 1979, all subjects and themes for public art were determined by the government. These invariably included one or more of the three basic human elements of Communist China: peasant, worker, and soldier. Other significant subjects included martyrs who had died for the Communist cause and, of course, Chairman Mao. Often Mao statues were created anonymously, sometimes by untrained stone carvers. Many have been torn down in recent years, much as Lenin statues have been dismantled by Russians. I was able to locate and photograph a number of the remaining Maos, many of which probably have a short future.

Wang Keqing spoke of the period from the late 1950s through the 1960s, when most of the Mao statues were created: "Few works were done after the major projects of 1959 during the Great Leap Forward [1958–60] and the Cultural Revolution of the 1960s. During the Great Leap Forward many sculptures were done by peasants, not professionals, and they often were not very successful. So from 1950 up to 1959 there were not many significant projects. The government did not commission works during this period, and there was little discussion about public art at all. The sculptors went back to their provinces, teaching school and doing their studio works. After the major 1959 projects, the same thing occurred. Not many commissions, no more public art."

During our interview at the Guangzhou Academy of Fine Arts, Pan He also shared his reflections on this period: "Fifty years ago there was no hope at all for sculpture in China. The real hope has been only in the past ten years. During the sixties and seventies there was no chance for a sculptor to do public art either, no opportunities. You would send a sculpture to an exhibition in a museum, and maybe it would get accepted. But there was not a single large-scale project going on. We teachers came back from

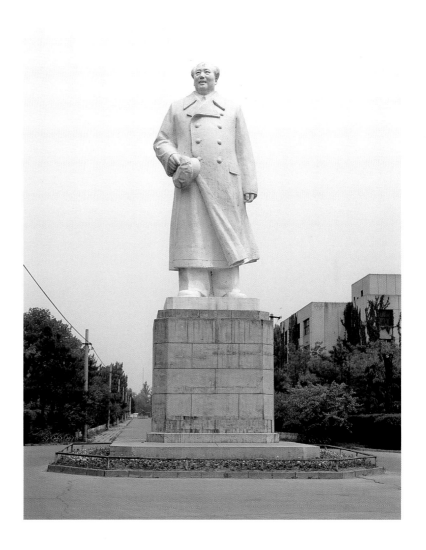

foreign countries in the 1950s to teach, and our students grad-
uated, and all they could do was teach. There was no work for
them. So these young teachers taught their students that there was
nothing to do except teach! This became a negative circle. We cre-
ated lots of teachers who had no real work opportunities. It was like
raising cats—we raised lots of cats, but there were no rats to catch
because there were so many cats. Cats were everywhere, but no rats.
I was extremely frustrated with the situation during this time."

Zhang Yonghao addressed the productive period of the late 1970s: "In 1979 the Central Committee of the Communist Party held a conference in Beijing. The principles of this conference were set by Deng Xiaoping and the Central Committee, and they talked about 'opening the gates of China.' Many people called it the 'Thought Liberation Conference.' All aspects of life and politics were discussed. It was a major turning point for China politically and economically. We went from a closed-country policy to an open one.

"The major point was to examine recent history to see if Mao's theories really worked in practice—if the results were not good, then the idea was not good. Not all of the theories worked, so this conference instituted changes. It got rid of the bad parts of Chairman Mao's theories regarding isolationism, economics, and intellectual life. There was a great response from the art community. Local art committees held similar conferences in their cities to carry on the spirit of the central conference. Artists felt they could start doing things they could not have done before. We gained more personal freedom to express ourselves. And we started to look back and conduct research.

"We studied the [Buddhist] stone carvings at Dazu [Sichuan, 9th–13th cent.] and Yungang [near Datong, Shanxi, 5th cent.], looking for influence from ancient China. This had been prohibited before. Since it was more open in the arts, in our works we began to explore our own Eastern history combined with our Western training. We began using a Tang-dynasty technique to sculpt a line, for example. Or, as in traditional Chinese sculpture, artists tried to take away as much negative space as possible, creating a single unified piece. This was not typical Western-style realism. Looking at our heritage was not prohibited any more."

Ye Yushan, former director of the Sichuan Fine Arts Academy, presently a representative in the National People's Congress (loosely analogous to a U.S. Congressmember), the most renowned sculptor

in China, and a participant in the 1979 conference, shared some of his own historical observations as we drove from Deyang to Chengdu in Sichuan Province: "One of the important issues of the 1979 conference was to criticize Chairman Mao. Before, the Communist Party said that whatever Mao said was always right. We should follow whatever he said. At this conference, Deng Xiaoping said, 'Whatever Mao said that is right, we will do. If it's not right, we won't do it.' The effect on art was tremendous. Before, art was required to have subject matter. But during this conference they said this was wrong—it's OK to have subject matter, but it's also OK to have art without subject matter. That was really great for us, a liberation. It gave lots of freedom to the artist. Another major theme of this conference picked up on something Mao himself said: 'Let a hundred flowers bloom.' That was a good direction for the arts in China. One hundred different types of 'flowers' would make for rich diversity in all of the arts."

Yuan Yunfu, the painter responsible for one of the most significant murals in the Beijing Airport, done just after the 1979 conference, expressed the exhilaration of the art community: "We were like fish thrown back into water."

Wang Keqing said of the period following the "Thought Liberation Conference," "We realized that we had to have some kind of institution to help the government understand and execute public art. We showed officials the importance of public art and explained that, compared to ancient times, there was very little public art done in contemporary times. In 1982 the Chinese government approved a proposal made by the Chinese Artists Association, under the leadership of Jiang Feng, Liu Kaiqu, and Hua Junwu, to establish the National Guidance Committee for the Construction of Urban Sculptures and a related artistic committee. Since then, public sculpture has developed vigorously in all parts of China. In the following ten-year period, over four thousand public sculptures were created.

"Why would the government listen to us? Well, we wrote a proposal signed by the already-existing Chinese Artists Association. The older generation of well-known artists wrote the proposal. They convinced government officials that public art is a direct expression of culture. It captures the spirit of a civilization and is therefore part of the educational mission of this society. The government saw the importance of this and saw that public art and sculpture were the history books of Chinese civilization. They realized that the art left by all ancient civilizations, from the pyramids of Egypt to the great classical figures of Greece, carry the rules of its society. This was a very important step, and we sculptors felt our job was very meaningful. Our work would hold great meaning for the present civilization and the future, and our dreams as sculptors would become realized, too.

"This central committee was appointed by the federal government's Cultural Affairs Department and the Construction Department. Liu Kaiqu was the original artist organizer, and there are many professional experts from the fields of art, architecture, landscape architecture, and art criticism on the committee. There now are thirty experts on this committee, and we are planning projects all over China.

"In all provinces and cities there are equivalent public art committees. Our work is to direct and assist them in creating new projects. For example, Shanghai has its own public art committee led by an expert sculptor. The structure of that committee imitates our central committee, and they function under the same regulations. They report to our central committee. Every year the city gets money from the government and these experts decide where to put public art. Our committee's main responsibility is to instruct; we show the cities' committees how to function, and we coordinate their efforts. For example, in the 1980s many cities wanted to do statues of Lu Xun. They wanted to do them everywhere. But the central committee said, 'Let's do only one really good one, and it

should be placed in Lu Xun's hometown. That would be the most appropriate location.' We told the other local committees to do more appropriate things with their money, which they did. Another example occurs in wintertime, when every city wants to create a swan statue, a customary symbol for the winter festivals. We always have to stand up and say, 'Stop this.' We function as instructor, coordinator, and quality control.

"When a state-owned company has some money left over and wants to build a statue, we get involved to find out what they're doing. We want to monitor the quality of the art and make sure that the artist doing the project is certified by the government and is qualified to do the job. Or sometimes an institution or factory will ask us to recommend ideas and artists. Rarely, a project will occur that we don't know about and sanction, like private commissions nowadays. If the work is of good quality, that's OK, even if it wasn't in our plan. But sometimes the work is of poor quality, and there's not too much we can do about it. The local television and media will ask us our opinion, however, and I will openly criticize poorly done works."

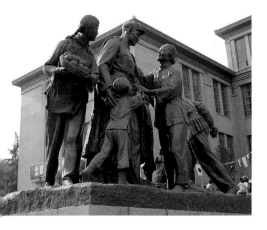

Being as Close as Fish and Water. *Anonymous collaborative work. Metallized concrete; 1990s; People's Liberation Army Military Museum, Beijing*

The title of this work, a phrase from the 1960s and 1970s, means that the Communist Party, like the fish, cannot survive without the support of the people, the water. This is a two-element sculpture; the works are on opposite sides of the entry plaza.

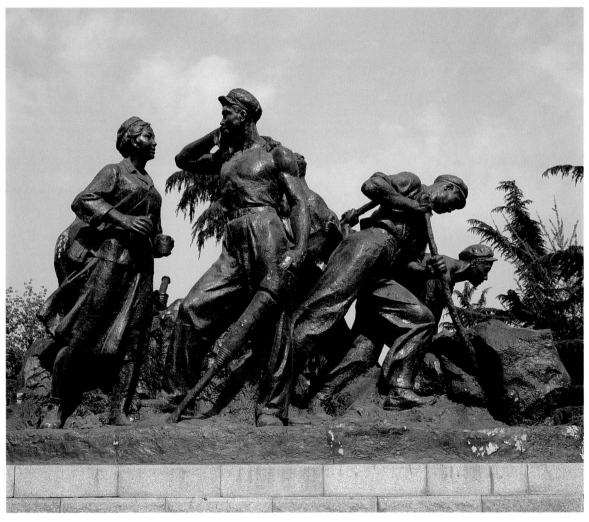

Waking Lion. *Pan He, Lian Mingcheng, Cheng Yunxian. Fiberglass; 1987; War of Chinese People against Japan Memorial Hall, Beijing*

Cheng Yunxian described the evolution of the project: "This sculpture was commissioned to commemorate the fiftieth anniversary of the Sino-Japanese War. We first thought about making a grouping of figures. But a few figures could not express our feelings. The war against Japan created very powerful emotions—anger, independence, aggression. So the piece had to be very strong. Since the museum was built near Lugou Bridge, where the first fighting of the war broke out, we were inspired by the ancient carvings of lions on the bridge. It has been said that China is like a 'waking

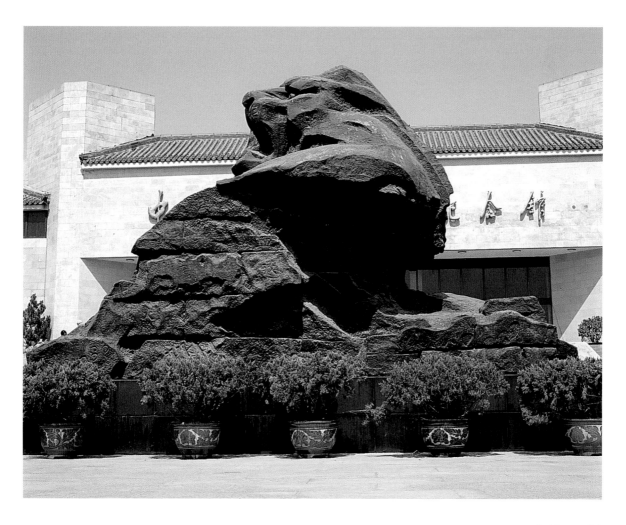

lion' who had slept for a thousand years. One day, the lion woke up. The power and emotions from the people were strong.

"Right from the beginning we eliminated the idea of creating a realistic lion. We figured that a lion alone was not an appropriate symbol to represent China. We began to think in a freer way, incorporating elements of the Great Wall and creating the sense of a historic remnant. We decided to make it rough looking and, by including gunshot marks on the walls, to let the people feel the history. The piece began to take shape in our minds as something not abstract, but not realistic either. At first, people did not see the relationship to the Sino-Japanese War, but over time they have realized its power as a symbol."

Asked about the collaborative process so often used for large monuments, Cheng responded, "Collaboration exists for historic reasons or needs of the artists. Large projects are simply too hard for one artist to handle. Once the government decides on the subject matter of a proposed monument, it selects the team of artists. This team works on how best to express this idea. Each member goes back to his studio to work on individual ideas. After preliminary ideas are sketched out, we meet again to review the designs. As a group, we determine which design is the most appropriate. Every artist has equal weight in deciding which design will be picked for further development.

"We all work together with the same goal, to come up with the best result. We each respect any good design. Do we argue? Of course—there should be arguments. We resolve conflicts among individual egos because the final design is never that of only one artist. Parts of everyone's design are incorporated. This is part of the Chinese artist's character. When we practice our own art, we each have our own distinctive style. But when we work on a public project, we collaborate, respect each other, and we give up our own personal egos in order to arrive at the best design. We must respect the good ideas of other artists. What matters the most is the end

result, not who did it. The original design for *Waking Lion* was done by Pan He. The group added new components and new ideas. All of the artists worked on the final maquettes together. It took fifteen maquettes to get to the finished model.

"In recent years, there has been a change in the way work is commissioned. Collaborative work is good, but it is not being promoted now. A big project will require the assistance of other artists, but not *all* projects will."

Collaboration is not always perceived to go smoothly, however. Several artists reflected on the realities and challenges of this type of work. Wu Huiming of Shanghai, who has worked on both large solo projects and collaborative works, explained the difference: "On large-scale sculptures you need assistance to carry out the project. I believe the best way is to have one artist and several assistants. Collaborative pieces are a huge hassle, and it's difficult to get a concentrated, integrated final piece. As artists, we all have strong personalities and different approaches, and we are forced to work together to come up with one design. It's really tough. Each is, individually, a great artist. When you put them together you get a strong team, but to unify this team is really difficult."

Phoenix Ascending the Sky. *Yang Yingfeng. Stainless steel; 1990; Olympic Center, Beijing*

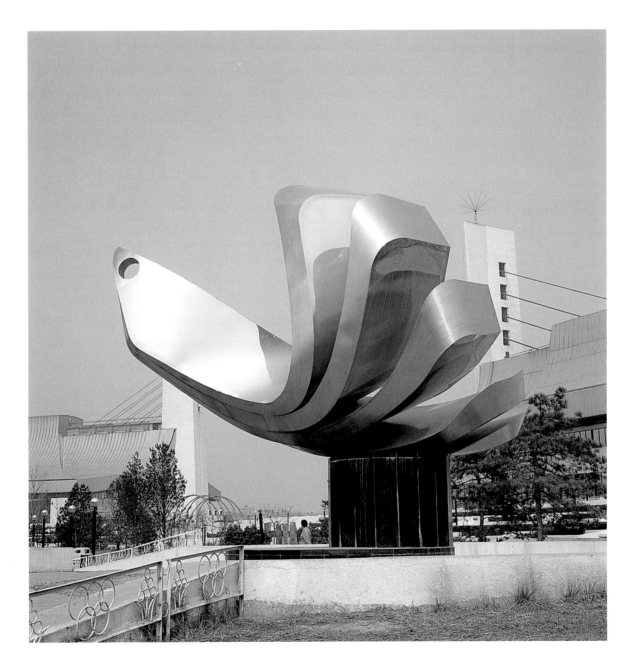

One of many public sculptures commissioned for the 1990 Asian Games held in Beijing, this is an example of abstract sculpture, now frequently found in China. Usually made of stainless steel, fabricated bronze, painted welded steel, or carved stone, these works are reminiscent of abstractions created in the United States during the 1960s and 1970s. Symbolic of the site or the event they commemorate, they often include a ball, representing the globe and wholeness, and images of flight, apparently representing spiritual freedom. Abstract symbols commonly are mixed with human figures.

After seeing dozens of similar images, I was struck by the formulaic approach of much of this art. Very little abstract sculpture expresses the contemporary notion of involvement with materials for their own sake popular in the West and Japan. Almost all of the works represent the mission of the institutions—satellite stations, newspaper publishers, flight schools, and sports complexes, among others—at which they are sited.

Several of the artists I interviewed commented on abstract art. Wang Keqing noted, "Abstraction has always existed in Chinese art, and I believe that it originated here. In ancient China, abstraction developed from pictographs inspired by real-life phenomena and the observation of celestial bodies. Abstract art was embodied in totems for worship and in patterns on articles of daily use. Chinese characters took their shapes from the gradual evolution and abstraction of pictographs. But our abstractions are different from those in Western art. We consider more of the spirit [of the subject]."

Ye Yushan, however, during one of our long drives between cities in Sichuan, echoed my own concerns: "Many younger artists are doing contemporary abstract art, and this is very positive, but they often imitate Western style and lack the true spirit of Western abstraction."

Many abstract artworks were done by artists who were trained in the figurative traditions of the arts academies but produced both

portrait commissions and abstractions. Such versatility is rarely seen among Western artists, who tend to specialize in one genre. In addition, Chinese selection committees apparently didn't mind basing their decision to commission a well-established figurative artist to work on an abstract project solely on the evidence of prior figurative works. Ye Yushan, for example, who was known for his social-realist figurative sculpture, told me as we stood in front of a winged abstract work he had created for a flight school, "I believe that when a sculptor is dealing with different subjects or sites, he should be able to use different artforms to express a particular subject. I want to be able to change my personal artistic style to suit the conditions."

Abstract art often has been considered less controversial than figurative work. As Tan Yun, a forty-year-old abstract and figurative sculptor from Chengdu, explained, "If people can identify a subject in a figurative work and they don't like that individual, for whatever reason, then the artwork is not liked, even if it is a well-executed figurative sculpture. With abstract shapes, this isn't a problem."

Structure. *Sui Jianguo. Stone and steel; 1990; Olympic Center, Beijing*

This is another example of art commissioned for the Olympic Center. Many public works adorn this large sports complex, set amid buildings, plazas, sports fields, and running tracks. As we strolled with Cao Chunsheng through the extensive sports complex, Yu Huayun, the thirty-eight-year-old vice-chair of the Beijing Public

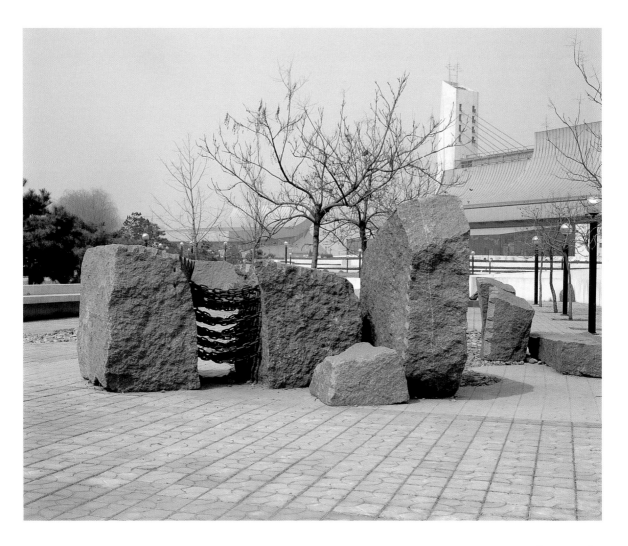

Art Committee, explained the selection process: "There are two ways public art is commissioned. One way is to find a good piece that is available and then find a site to suit the piece. Another way is to have a site available and then ask an artist to create a site-specific work. Every year there is money available from the government, public donations, and construction budgets. For most projects, a site and an artist's design are chosen, and the artist submits a budget. Then we decide if the budget is reasonable.

"For the Olympic Center, the money was raised first. The committee then toured the grounds with the architect and determined which sites would receive artworks. For the Asian Games, the participating nations donated 1 million yuan for these projects. The sculptors and fabricators also donated much of their time and materials. Some of the artists did not want any compensation, but we gave them a modest fee anyway. This was great international exposure for them.

"Sculptors visited the Center and then either created proposals for sites or submitted existing works for our review. We received two hundred entries, and we asked the artists, architects, planners, and our committee to pick out the best twenty. We received entries from all parts of China.

"Sometimes we run open competitions. We send out prospectuses to all of the arts institutions to let them know the parameters of a project. The artists then submit original proposals, drawings, and models. We pay those artists who submit serious site-specific proposals. Let's say we receive thirty proposals. We vote the best ten, then the best five, until we arrive at the winner. Or sometimes we do the opposite—we vote the worst ten, then the worst twenty, until we get the winner.

"The funding comes from the agency or institution that is receiving the work, or from the districts within or around the city. Our committee does not fund projects. We only administer and oversee them for the district governments or whoever is sponsoring the

work. We receive funding only for administrative expenses.

"There are twenty-five districts in Beijing, and each is required to complete one project per year, so in just four years there will be over one hundred new pieces installed around the city. For each project there is a selection committee including the architect, government officials concerned with the project, and usually at least two artists. The architects are very easy to work with, in general, and take the lead from the artists.

"The future for public art in China looks very promising. Public art is developing at the same rapid pace as our cities. We are hoping that our artists will create a type of art that integrates our unique culture and expresses the new era of economic reform and faith in the future. We have a saying, 'National tradition, local character, and spirit of the era.' This best describes the direction of public art in the 1990s."

Vigorous Man Fighting the Bull. *Ye Ruzhang. Cast iron; 1990; Olympic Center, Beijing*

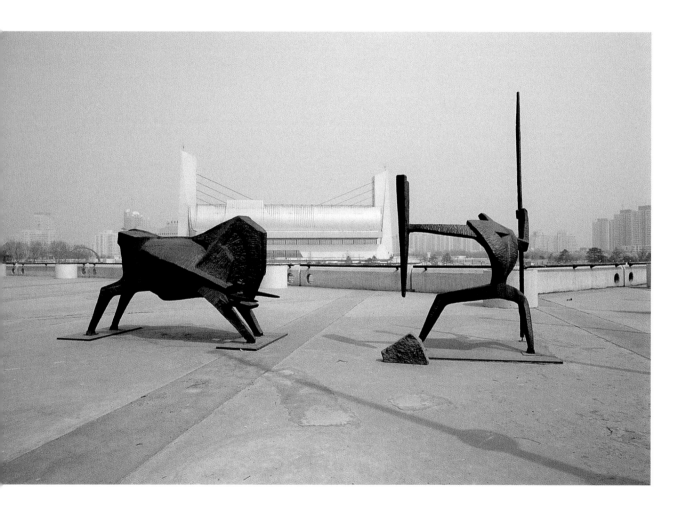

Seven Stars Meet the Black Pawn. *Shi Yi. Fabricated bronze, mixed media; 1990; Olympic Center, Beijing*

It is said that in the history of Chinese chess there have been only two matches that resulted in a tied game. This environmental work depicts the position of the pieces during those matches.

Sidewalk. *Zhan Wang. Fiberglass; 1990; Olympic Center, Beijing*

The least-common category of Chinese public art, which I call "contemporary/progressive," is practiced by a handful of young artists who are exploring new artistic territories and at the same time have the backing of their society—no easy feat. These works deal with 1990s cultural issues. The thirty-three-year-old super-realist sculptor Zhan Wang, for example, portrays a middle-aged, pot-bellied man as he truly is, not as a perfect hero.

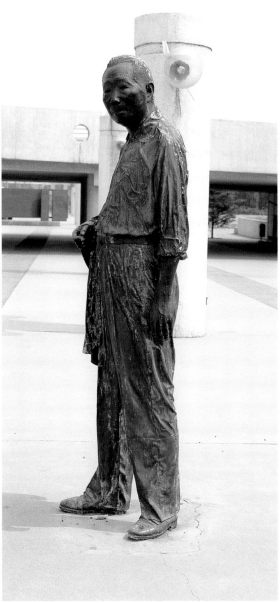

Seduction Series. *Zhan Wang. Cloth and glue; 1994; Beijing*

Building Performance.

Zhan Wang et al. 1994; Beijing

Some artists are creating temporary installations that deal with concerns of the fledgling ecological movement in this overcrowded and environmentally ravaged country, or with property and development issues amid bursting national growth. Zhan Wang recently completed a performance/installation work in which he attempted to restore a recently demolished building whose site was soon to be occupied by a new skyscraper. He polished ceramic tiles on the ruins, repainted door trim, and repatched and highlighted mortar between bricks in collapsing walls. Demolished buildings and new construction are evident on almost every block in downtown Beijing, where the resulting dust, the pollution, and the din of feverishly paced construction activities pervade the environment. Zhan

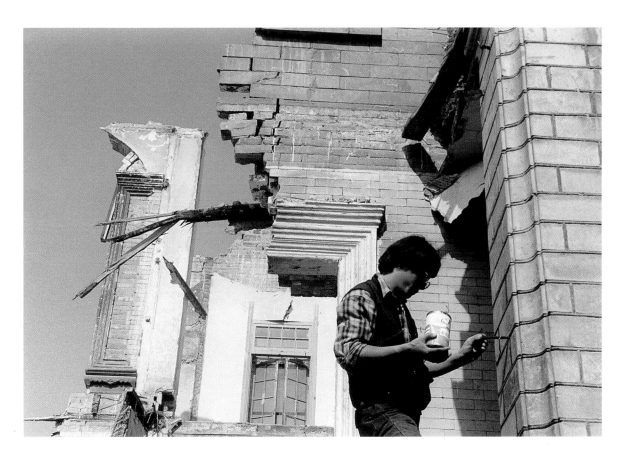

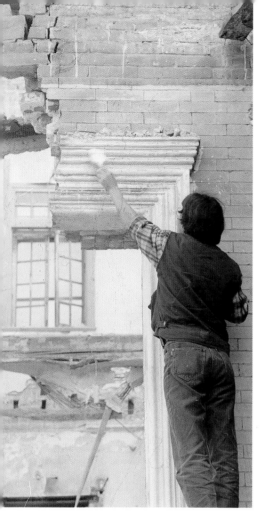

Wang's areas of attention stood out as poetic reminders of the old culture and architecture that are rapidly vanishing and being replaced by international development projects.

These artists are on the cusp of using art as their Western counterparts do to look hard at their culture and publicly critique it, something that has not occurred in China for over half a century. One never knows how long these brave individuals will continue to be sanctioned or tolerated. One poignant example is the artist Xiao Lu, who did a performance/installation work involving a telephone booth and firearms. Although private citizens are not allowed to own handguns, she procured one from her soldier boyfriend and collaborator, Tang Song, and used it as a tool to interact with the telephone booth. As part of the work, they destroyed the booth by shooting the gun (no one was injured, of course). Possibly as a result of pressure and criticism following this intriguing and provocative work, Xiao is now "exiled" and living abroad. When my assistant telephoned her family to seek her phone number for an interview, her mother refused to give us her whereabouts. It remains to be seen whether artists like this will be able to tackle some of the thorny issues—such as infanticide, prison conditions, women's rights, and family rights—that exist in China today.

Landscape in Sichuan. *Yuan Yunfu. Mural; 1979; Beijing Airport*

One of the most notable artists exploring the combination of traditional and contemporary issues is the muralist Yuan Yunfu. His dramatic paintings, ceramic tile murals, and tapestries are found in airports, subway stations, and atriums of high-rise buildings throughout the nation. Often incorporating traditional Chinese

painting techniques, his murals reflect modern China and include freighter ships, space travel, and the contemporary urban landscape. Ancient Chinese aesthetics combine beautifully with modern imagery in his works and poignantly reflect a culture experiencing rapid change.

In his Beijing apartment, this visionary and extremely articulate artist discussed the origins of his unique style of work: "There are two aspects of art in China. One is that we have to insist on being independent, purely nationalist in theme and style. The other is that some artists believe that Chinese art is too old, out of fashion. We need some new blood, some new Western influences to substitute. These two points of view were discussed even during the Cultural Revolution. Artists spent a lot of time studying the oil painting from the Soviet Union. So the Xu Beihong school of painting was closely combined with Soviet style to create a new school of art.

"Now there is much more freedom. Art is getting multi-directional. But it is much more challenging. Before, for example, with all of the Chairman Mao statues it was easy because there was always only one voice, that of Chairman Mao. That's why everyone could work together. Now you cannot do that—with a thousand people and a thousand different thoughts and directions. Now there are different points of view, aesthetic disputes, different schools of thought all struggling to take hold. Now there is the concept of individualism, which is highly valued. But only if the artist is good and talented, of course!" he jokingly added.

This is the same artist who, during the Cultural Revolution, was sentenced to serve two years at a "re-education" camp in the remote northwest for painting a flower in the ancient, traditional style, which was forbidden by the Gang of Four for being bourgeois. Yuan is presently the director of the Public Art Program at the Central Academy of Art and Design in Beijing, one of the most progressive-minded arts academies in China, which special-izes in public art studies. In most of the art schools today, there are

two departments with separate faculty and students: the painting department focuses on the entire range of contemporary painting, and the traditional Chinese painting department keeps ancient skills and techniques alive.

Standing in front of his controversial mural, Yuan described how the airport project developed: "After the 'Thought Liberation Conference' in 1979 we all felt liberated by this political reform and climate. We felt the taste of freedom, the taste of freedom of expression. So a bunch of artists gathered here at the airport. No one really knew we were living and working out here, since the airport is far from the city. It was not our purpose to keep it a secret, but just to keep it quiet. The director of this team was the head of the airport construction committee. He was living out here, too. He first got us involved by visiting the Central Academy of Art and Design, where I teach, and he held a conference with all of the professors. He said, 'Come join us to work on this project.' He asked us to do whatever we wanted, no restrictions. His name is Li Ruihuan, and today, in 1995, he is one of the top leaders in China, the head of the Communist Party Propaganda Department.

"We painted from morning until midnight. We all put ourselves deeply into our work, and our spirits were high. I had just returned from a three-month journey exploring the Three Gorges of the Yangzi River with Wu Guanzhong and Huang Yongyu, two of the most renowned painters in China. I was inspired by the cultural history of the Yangzi and the Gorges. So many great artists, intellectuals, and poets received inspiration from the beauty of the river. This kind of image had not been allowed before. The Gang of Four criticized anything involved with beauty, calling it 'black painting' or 'evil painting.'

"In fact, in 1973 I first proposed the idea of painting the Yangzi River for the new construction of the Beijing Hotel. It was originally approved by Premier Zhou Enlai and by Guo Moruo, a well-known official and scholar. But then the Gang of Four openly

criticized my proposal and me, so the project never happened.

"The airport project meant a lot to me since I had been criticized for the [unrealized] *Long Journey of the Yangzi*. So we painted it here with new meaning, for my own artistic career and for the future of art in China. I was interested in combining certain Western painting skills with traditional Chinese ones. I used the perspective found in Chinese painting, which is characterized by a feeling of flatness. Traditional Chinese painting never employs this kind of rich color, however—I definitely used Western-style color and light. So this became a new style of painting for me—Western/Chinese Painting. It was very exciting to make a new discovery in exploring a synthesis of Eastern and Western art. Some art critics, as well as a group of artists, believe that we Chinese need to keep our traditions and culture, but it is also important to import some parts of Western culture and new ways of expression. Another component of this work is the combination of traditional Chinese landscape subject matter with modern imagery like freighters and urban views along the river. This represents China entering the modern world.

"While we were working on the painting, it was difficult to use black and white—traditional Chinese ink—to draw this mural. It wasn't strong enough. Oil painting wasn't quite right for this piece, either. Director Li seemed to have a real understanding of artists, so we made a special request: 'We need a new type of paint for this project. We need Rembrandt Paint from Holland.' So he sent an airplane to Hong Kong and it brought back a planeload of the right paint! The painting was based on our sketches from the trip. We had hundreds of drawings, but no photographs. None of us owned a camera at that time. The project took one year from design to completion."

Water Splashing Festival.

Yuan Yunsheng. Mural; 1979;

Beijing Airport

Yuan Yunfu shared a similar experience regarding another mural project done at the Beijing Airport during this period by his brother, Yuan Yunsheng, also a well-known painter. The controversy around Yuan Yunsheng's mural generated national discussion regarding moral and ethical good taste and censorship. "Like much

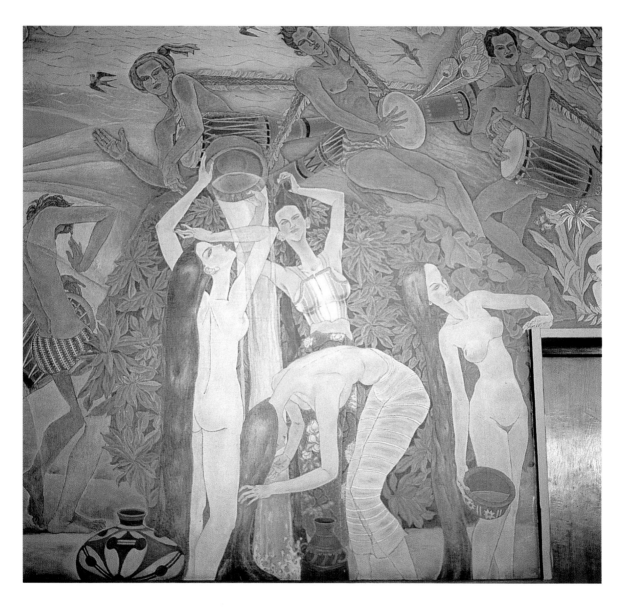

of Chinese painting," Yuan Yunfu explained, "my brother's mural contained symbols that had political implications. The subject matter is the [Dai people's] traditional Water Splashing Festival, in which you throw water on your body to clean all the evil away, clean off the past, and begin a new life. It was painted in 1979 when the Gang of Four was denounced. It was intended to have an educational meaning, too, as all public art should. The mural depicts an unclothed woman from the Dai (Tai) ethnic minority [the largest such group in Southwest China]. A controversy developed because of this nude. Some important leaders were uncomfortable with it. In traditional Chinese culture, bodies are never exposed. Former Chairman Hua Guofeng had a huge problem with this nude. Deng Xiaoping was fine with it. We just hadn't seen the nude much in China. So Hua Guofeng made a big deal over it, and the nude figure section of the mural was officially covered up. It was decided as a compromise to cover only the nude, and to use a wooden board, rather than painting over or destroying it. It remained covered for several years. Recently the board has been removed because of a humorous incident. On the original wall on which the mural was painted, there used to be a clock, and the mural was simply painted around it. The clock was removed recently, leaving a round hole in the painting. The airport officials called Yunsheng and asked him to fix that part. He responded, 'I can't do that unless you remove the cover over the nude figure.' So they agreed!"

The History of Chinese Astronomy. *Yuan Yunfu and Qian Yuehua. Ceramic mural; 1986; Beijing subway*

This mural, which runs the length of a subway station, is located at the Ancient Observatory Museum.

Four Inventions in Ancient China. *Yan Dong. Ceramic mural; 1980s; Beijing subway*

This mural depicts the four great Chinese inventions: paper, gunpowder, printing, and the compass.

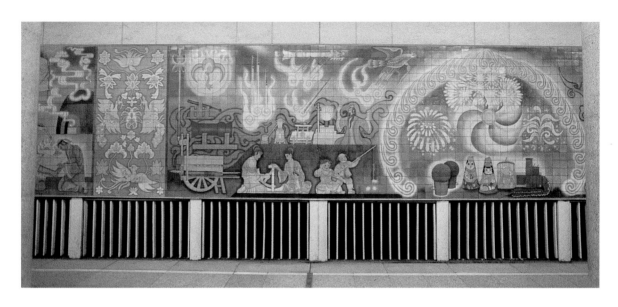

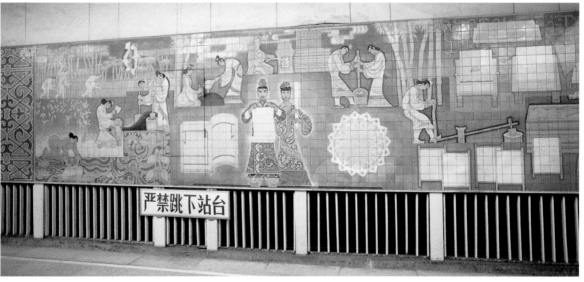

Badaling

Zhan Tianyou Memorial. *Liu Jilin. Granite; 1986; Badaling*

This relief at the Great Wall in Badaling memorializes Zhan Tianyou, the inventor of the railroad-car coupling device.

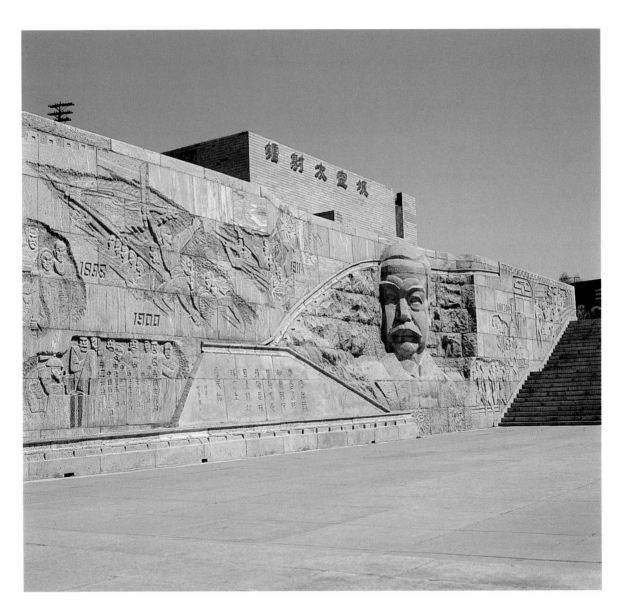

Shanghai

Song Qingling. *Zhang Dedi, Guo Qixiang, Sun Jiabin, Zhang Runkai, Zeng Lufu. Marble; 1984; tomb of Song Qingling, Wang Guo Cemetery, Shanghai*

Song Qingling, the wife of Sun Yatsen, was a major social and political figure. This portrait of her sits in front of a popular museum that celebrates the many achievements of her lifetime.

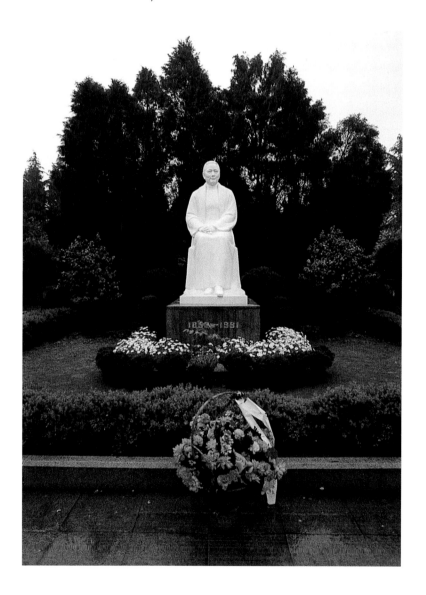

Marx and Engels. *Zhang Yonghao.*
Granite; 1985; Shanghai

This portrait of the founders of communism is the work of one of the great Shanghai social realist artists, Zhang Yonghao, who is also a portrait artist. A commanding and captivating man in his late sixties, Zhang has a sharp intellect and a comprehensive knowledge of Chinese sculptural history from its beginning. He is one of the country's most productive public artists, and the projects executed

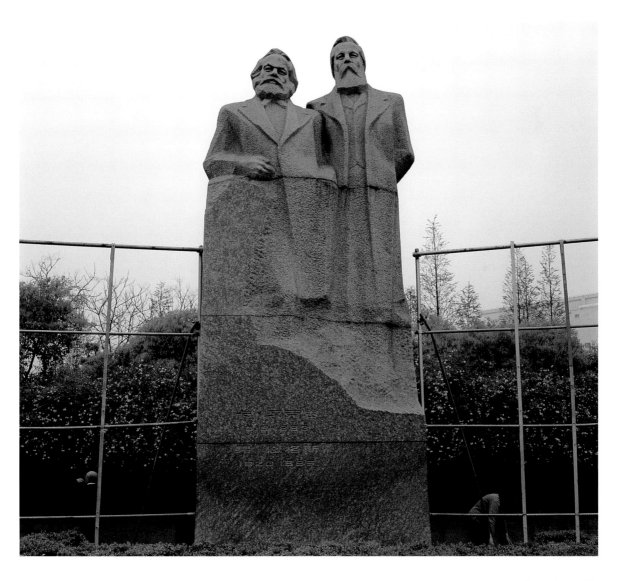

under his direction are among the largest and most impressive. He is also director of the Public Art Office in Shanghai, a wealthy city (as a result of its long association with international trade) with the most public art projects in progress. Its world-renowned Bund, the riverside promenade in the center of the city on the dramatic banks of the Huangpu River, has a half dozen recently completed projects, including several of enormous scale. Under Zhang's directorship, the Public Art Committee is extremely busy and well organized, and it employs some of the most knowledgeable art administrators in the nation.

Zhang Yonghao spoke of the different types of art now being practiced: "The government is still commissioning heroic monuments and glorifying its achievements. That happens everywhere, even in America. All governments do the same kind of monuments—independence monuments. Our society has many different types of art now—abstract art, art that involves politics, everything. I don't think that all art must serve politics, but art restricted from dealing with politics is not right either. In any society, it seems there is always something you must do for the society, either serving politics or whatever. Right now in China there are many different ways to serve society. Political monuments are one way, but there are other types of art that are useful these days. If we need a monument, we do that; if we need an abstraction, we go that way. Before, during Mao's time, the historic figures appointed by him were the only subjects a sculptor could do. Now we can do whatever we want. And we have more freedom in how we depict martyrs or revolutionary soldiers in our monuments."

Zhang described local selection procedures: "In Shanghai we have a People's Conference, which is like the representative system in the United States. It includes representatives from all municipal districts. These representatives might, for example, propose to build a monument for a group of war heroes. Then the city government would have to pass legislation approving the idea. The Public Art

Committee would carry out the details of organizing the project, once it was approved and the government had put the funding in place. We would set up selection committees to pick the artist and coordinate the project from beginning to end. This group of representatives is a very diverse lot, so they come up with wide-ranging subjects for monuments. For example, some of them are intellectuals, so they propose statues commemorating well-known scholars or intellectuals. Representatives who are painters suggest great artists."

Athletes. Zhao Zirong, Yan Mengxiong, Kang Qinfu, Yan Youren, Zhang Yibo, Mao Chengde. Cement; 1982; Shanghai College of Physical Culture Coliseum

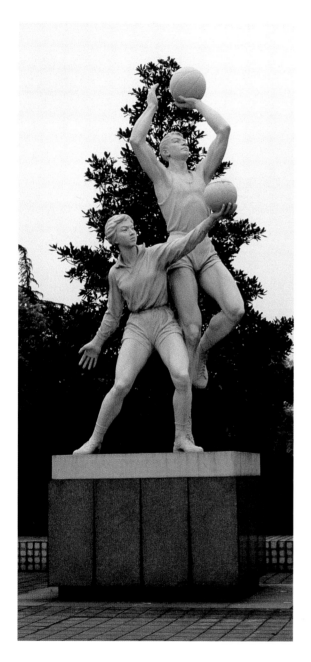
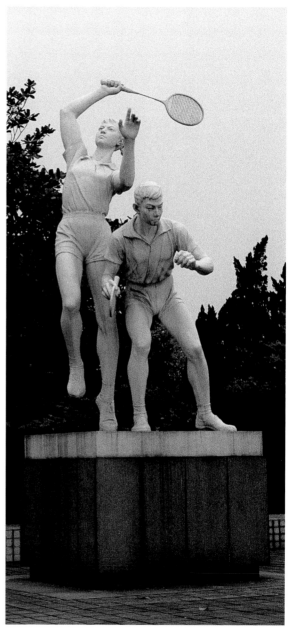

Mao Zedong. *Anonymous collaborative work. Stone; 1960s; Tongji University, Shanghai*

An interesting comment on the Mao statues of the 1960s was provided by Zhang Yonghao: "The monuments we're doing now are not just heroic figures or martyrs. We're doing inter-national poets, photographers, writers, painters, artists, opera singers. In the past this was considered 'worship of the individual.' It's kind of funny, because when you did that, it was called worship of the individual, but when you did Chairman Mao, it was OK."

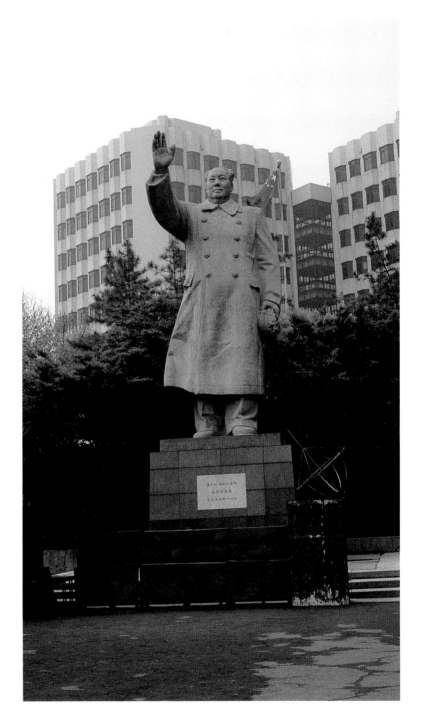

Huangpu Wave. *Zhang Yonghao et al. Bronze; 1990s; the Bund, Shanghai*

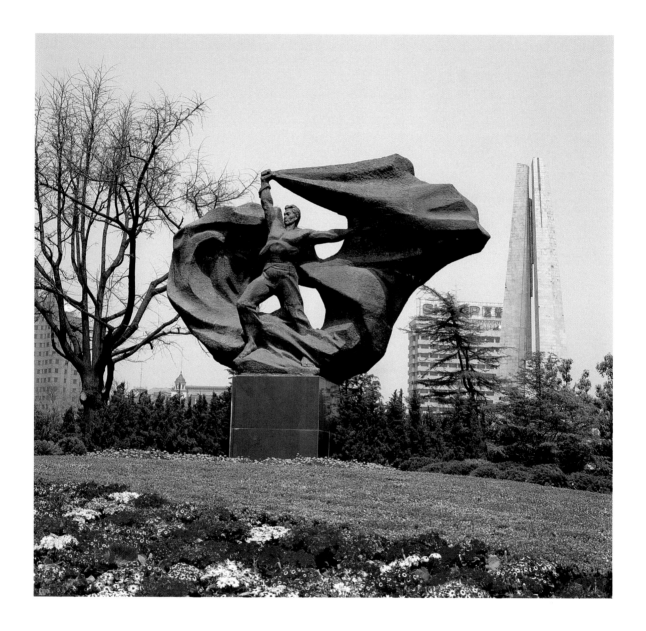

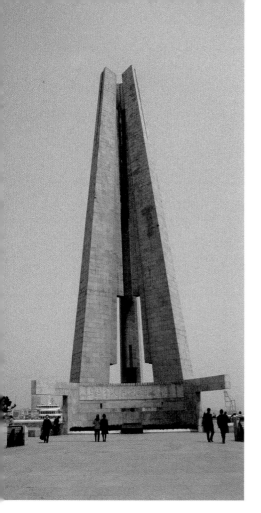

Shanghai People's Liberation Monument. *Collaborative work by Tongji University and Shanghai Urban Planning and Design Institute. Concrete and stone; 1994; Huangpu River, Shanghai*

The public art in Shanghai is an example of art being used to define the nature of the city by integrating it with some of the most prominent features of the urban environment. This work is part of the promenade along the Huangpu River in the center of the city.

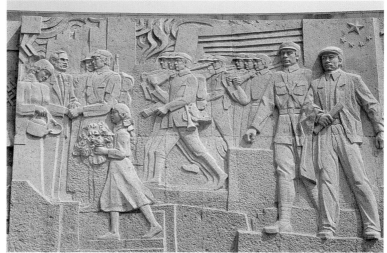

Monument to the May 30th Movement. *Yu Jiyong and Shen Tingting. Stainless steel and bronze; 1990; People's Park, Shanghai*

This monument commemorates the demonstrations that occurred in the International Settlement in Shanghai in 1925.

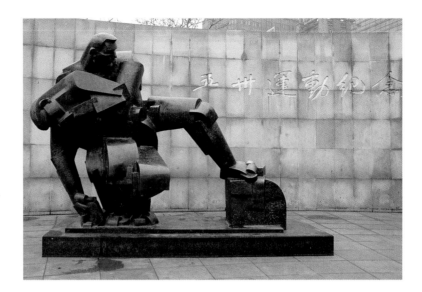

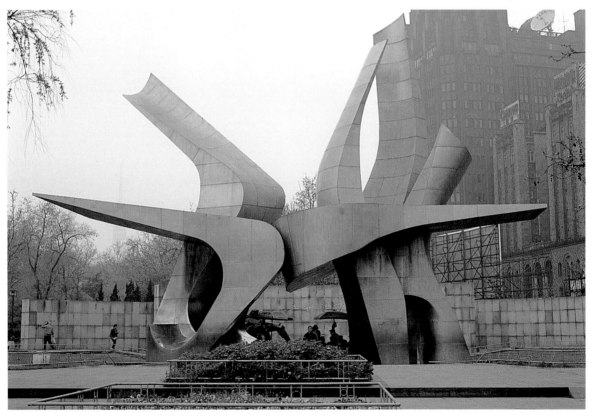

Dance of the Martyrs' Souls. *Liu Xunfa. Concrete; 1985; Shanghai Martyrs Cemetery*

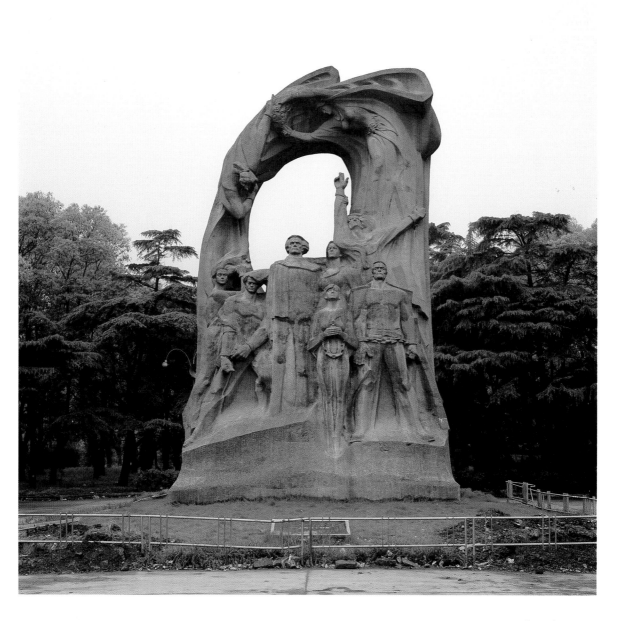

Mother and Son. *Tang Silu.*
Stainless steel; 1990; near Hengshan
Road and West Jianguo Road, Shanghai

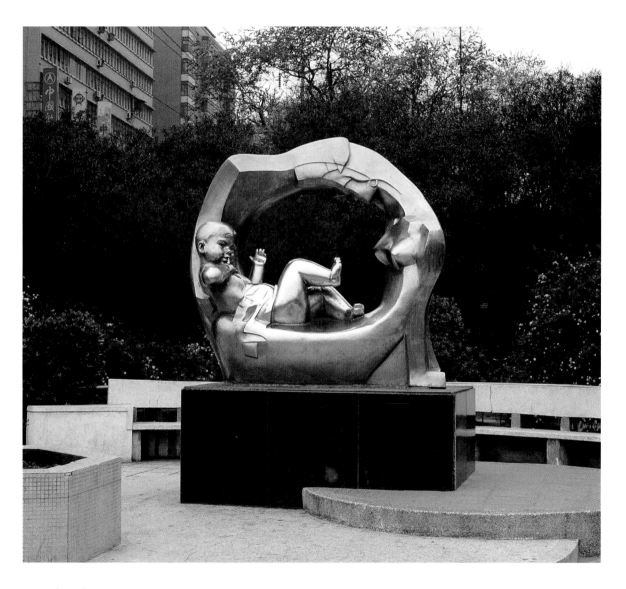

Nanjing

Yu Hua Tai Martyrs Monument. *Zhang Yonghao and Ling Yuhao. Granite; 1970; Nanjing*

Yu Hua Tai Park, also called Martyrs Park, contains this memorial to the one hundred thousand victims executed in Nanjing during Nationalist rule between 1927 and 1949.

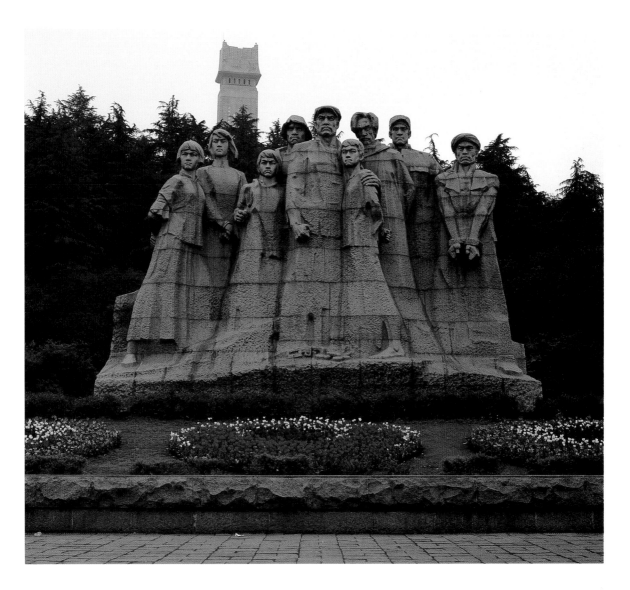

Nanjing Yangzi River Bridge Group Sculptures. *Collaborative work by the Central Fine Arts Academy, Beijing, and the Nanjing Fine Arts Academy. Cast concrete; 1968; Nanjing*

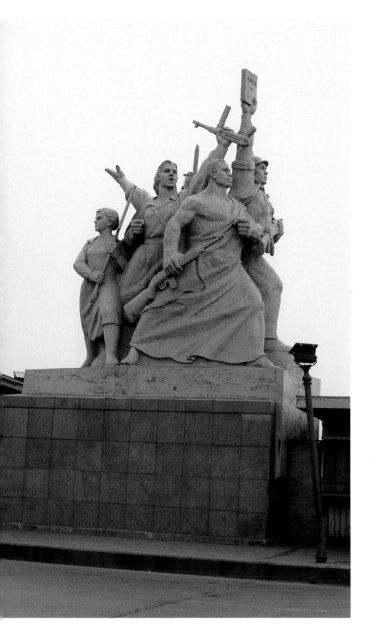

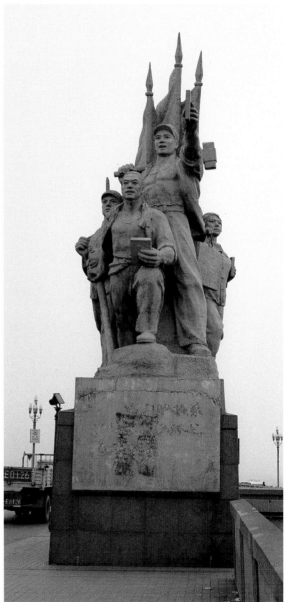

Nanjing Massacre Memorial Museum. *Qian Dajing. Granite and landscape design; 1985; Nanjing*

The Japanese invaded China in 1937 and during a six-week period killed three hundred thousand people, including children and pregnant women, in the city of Nanjing. This memorial museum contains historic photographs and artifacts depicting the terrible massacre. Outside, Qian Dajing created a powerful blend of sculpture, relief, and landscape architecture memorializing the victims, some of whose bones are displayed in a small, half-subterranean building.

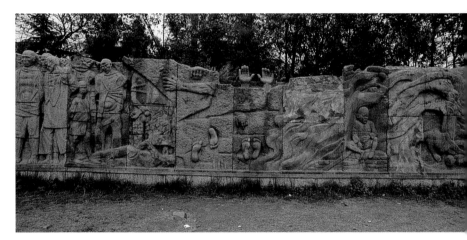

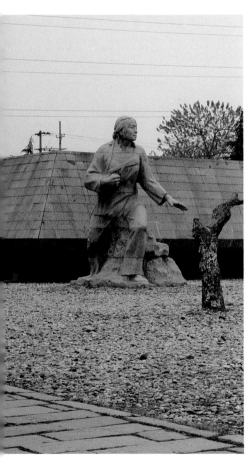

Wuhan

February 7, 1923, Martyr
Si Yang. *Cheng Yunxian. Granite; 1993; Wuhan*

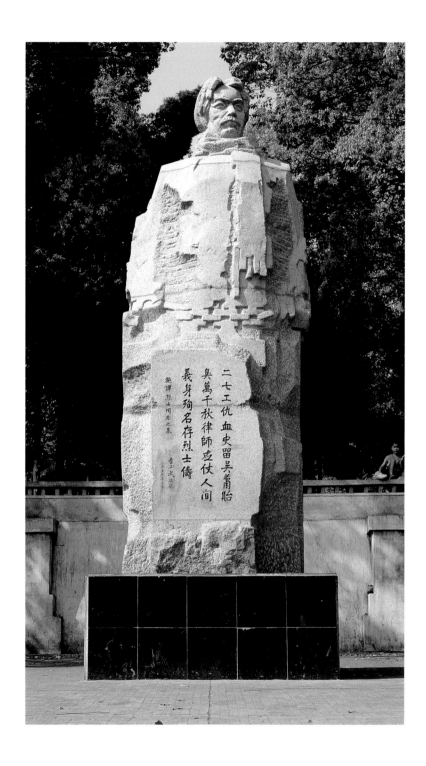

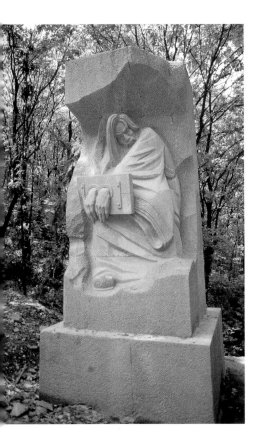

East Lake Sculpture Park. *Fu Zhongwang, Xiang Jinguo, Su Zaochun, Dei Huaijian, Cheng Yuchung. Sandstone; 1995; Wuhan*

This vast project involves dozens of large environmentally scaled and configured sculptures, in a natural lakeside setting, that depict the legendary history of Hubei Province.

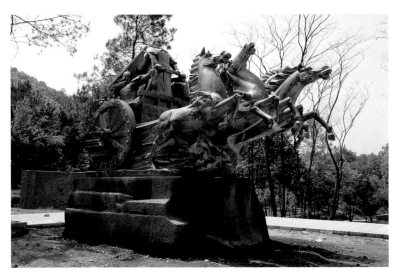

Zhu Rong. *Fu Zhongwang, Cheng Yuchung, Sun Shaochun, Xiang Jinguo. Cast iron; 1994; East Lake Park, Wuhan*

Zhu Rong, a legendary figure, was a minister to the Yellow Emperor in heaven. He is also called the God of Fire and is often represented as an animal with a human face.

Three Monks without Water. *Liu Zhengde. Granite; 1985; East Lake Park, Wuhan*

I searched for artists who seemed to be fully engaged in international contemporary artistic trends and issues and at the same time were creating works that were uniquely Chinese, works that spoke to their involvement with the current world community yet also dealt with the history and traditions of China. The best

example I found of an artist using twentieth-century stonecarving aesthetic and techniques to explore ancient traditional subjects was Liu Zhengde from Wuhan, director of the Sculpture Department at the Hubei Fine Arts Academy. This modest gentleman in his mid-sixties is one of the most artistically adventuresome artists of his generation. His depictions of legends that express moral teachings are marvelous combinations of the old with the contemporary. In the mid-1980s Liu was finally able to realize his dream of creating a series of sculptures illustrating these legends, the plans and drawings of which had been hidden under his bed in the 1970s. Eight of his unique granite sculptures now populate East Lake Park in Wuhan. Liu's works appear to me to contain subtle layerings of meaning and wit that could be read as commentary on bureaucracy.

This work illustrates the legend "Three Monks without Water." If there is only one monk in the temple, there will be water to drink because he will climb down the arduous trail to the river and struggle back up the mountain with a bucketful of water. It will be difficult, but he will do it to survive. If there are two monks, there will be water to drink because they will easily be able to share the load by carrying up the heavy bucket together. It is best as a two-man job. If there are three monks, however, all will die of thirst because each will spend all of his time and energy trying to convince the other two to get the water, and consequently no one will get it. Moral: "Applying many people to a task does not guarantee that it will get done." Also, "People tend to be lazy. If they can, they will always have others do the hard work." I believe Liu may also have considered the thought that there are too many bureaucrats and no one left to do the real work.

The Oil Salesman and the Archer. *Liu Zhengde. Granite; 1985; East Lake Park, Wuhan*

Another of Liu's works depicts the ancient legend "The Oil Salesman and the Archer." In an attempt to belittle the oil salesman, the famous archer boasted that since he was so highly accomplished and had superb abilities and coordination, he could easily perform the common task of the oil salesman, too. The oil salesman challenged the archer to pour oil without wasting a drop. This sculpture depicts the archer spilling oil all over the container. Moral: "Just because someone is an expert in one area, does not mean that he is an expert in all." This work, too, could imply that a bureaucrat who is an expert in governing in one area might not be capable of governing in all.

Blind Men Study the Elephant. *Liu Zhengde. Granite; 1985; East Lake Park, Wuhan*

The subject of this sculpture is the well-known story of three blind men arguing over the nature of an elephant. Each man, feeling a different part of the enormous animal, perceives the shape of the elephant very differently. Moral: "Just because someone clearly understands one part, does not mean that he understands the whole."

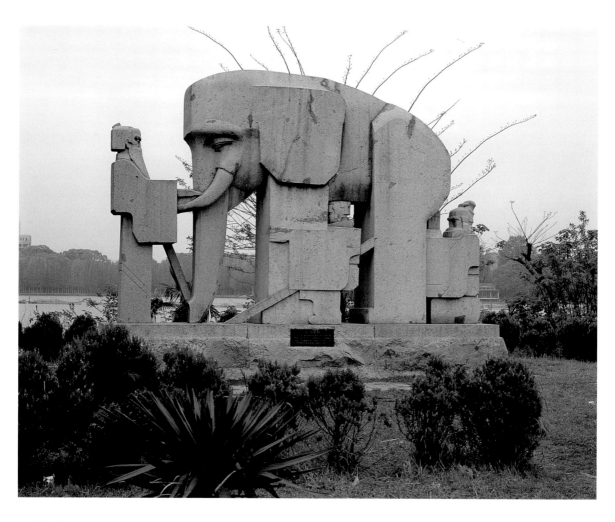

Walk Red. *Di Naizhuang. Environmental installations using thousands of red umbrellas; 1995;Wuhan (shown here), Beijing, Kunming, and other cities*

This artist creates vast installations with umbrellas in popular public sites in major cities throughout the country. His work is privately funded by a Hong Kong patron. Also depicted is *Crane* by Liu Zhengde, at the Yellow Crane Tower in Wuhan.

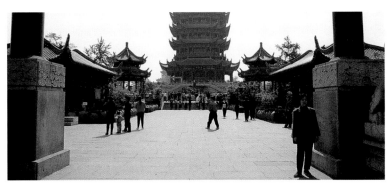

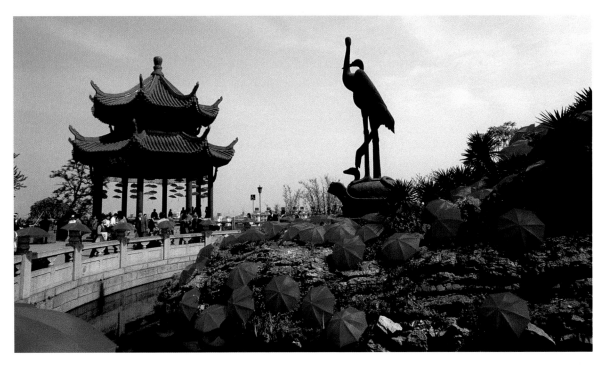

Guangzhou

Lu Xun. *Pan He. Bronze; 1987; Guangzhou People's Park*

Curiously, some of the works most highly revered by the public and the government have been expressive and poetic pieces produced by artists who managed to express subtle individuality despite governmental control. One such artist is the energetic seventy-year-old Guangzhou sculptor Pan He.

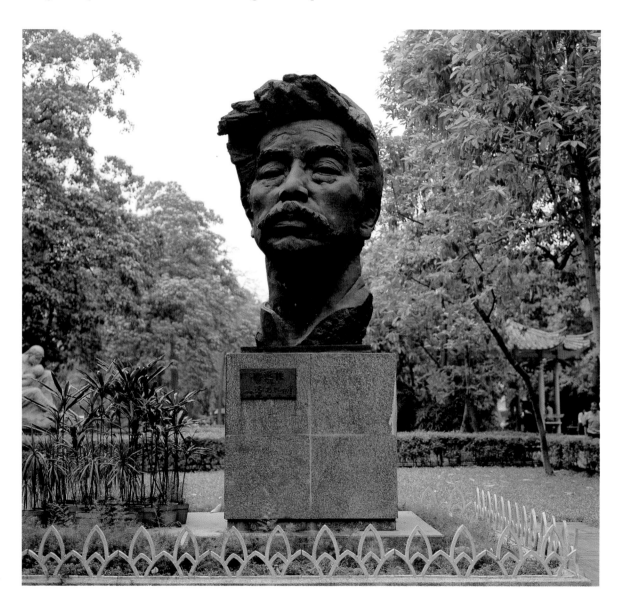

During the Cultural Revolution in the late 1960s and 1970s Pan, who as a young man had sacrificed his comfortable existence in Hong Kong to join the fight for communism on the mainland, was imprisoned by the Communist government and accused of being a capitalist sympathizer. He was "struggled against," paraded through the streets wearing a dunce cap, and made to crawl over broken glass on his hands and knees. Occasionally the government pulled him out of prison to use his talents to create a monument, after which he was immediately returned to prison.

In recent times, he has become one of the most celebrated artists in China, with numerous public and private commissions and the freedom to pursue his own choice of subject matter. In fact a mountain is being provided for him to carve, similar to Mount Rushmore in the United States. But Pan plans to wait to begin this large, remote project until he no longer has ideas for his own community, saying, "I prefer to be part of the public, part of my city and community."

Pan's portrait of the famous writer and intellectual Lu Xun, located in Central Park in Guangzhou, is a remarkable example of his talent as a sculptor and portraitist. By his own admission, he took liberties in portraying Lu Xun as an aloof and critical thinker on a level above the typical bureaucracy. Pan He views this piece as his own self-portrait. "Lu Xun had the reputation of looking down on bad people," he told me. "This piece is as much about self-expression as it is about Lu Xun. I wanted to do a piece about looking down on those people who put me in prison. Since I couldn't do a statue of myself, I 'became' Lu Xun in this work." When I asked him specifically about his years of imprisonment, I was surprised by his response: "In some ways, the Cultural Revolution was a good thing for me because it made me stronger willed to produce more artwork." Unlike most of the artists I interviewed who were over the age of fifty, Pan He is not a member of the Communist Party.

Five Rams. *Cheng Benzhong, Yun Zichang, Kong Fanwei. Granite; 1959; Yuexiu Park, Guangzhou*

This piece was one of the earliest figurative works commissioned after the Communist Party assumed power in China. It depicts a Guangzhou legend that tells how the gods delivered five rams, along with a small amount of grass, to this once desolate valley. The rams ate the grass and quickly spread the seeds throughout the region, making it the most fertile area in all of China. This piece serves as the landmark symbol for Guangzhou (Canton) the most important city in the province and one of the largest in China.

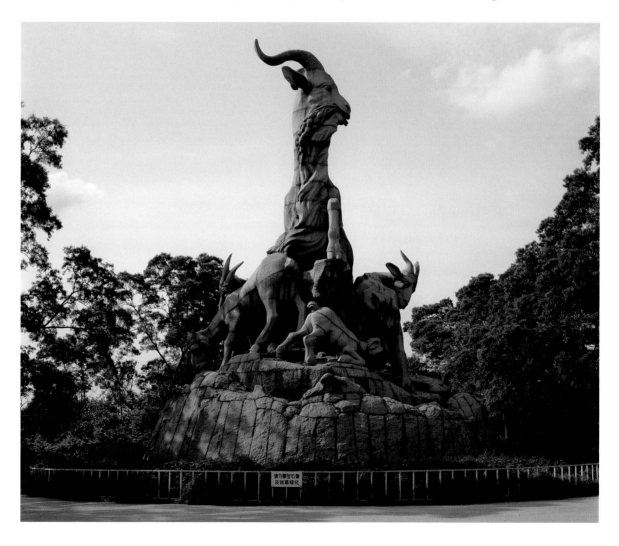

Sun Yatsen Memorial.

Yun Zichang. Bronze; Guangzhou

Dr. Sun Yatsen (1866–1925) was a native of Guangzhou. He led the 1911 Revolution, which overthrew the imperial system, and founded the Nationalist Party in this city in 1923.

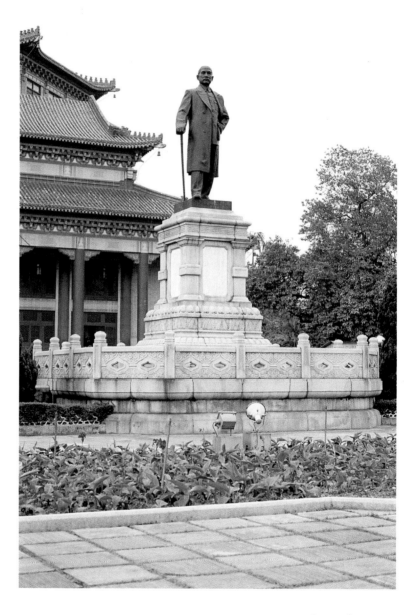

The Young Girl of the Coconut Woods. *Cheng Benzhong, Xue Qingzuan. Stone; 1987; Guangzhou People's Park*

As evidenced by her distinctive dress, the girl depicted in this sculpture belongs to one of the ethnic minorities of the Guangzhou region.

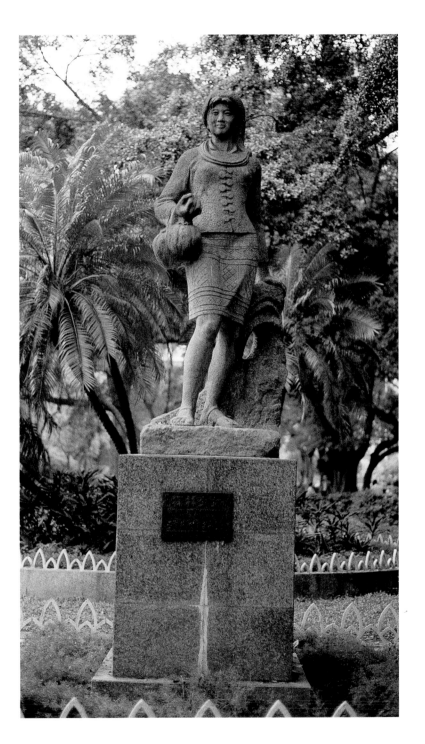

Guangzhou Uprising Martyrs Monument. *Yun Zichang. Cast cement; 1989; Guangzhou*

After Sun Yatsen's death, Chiang Kaishek became the Nationalist Party leader. In 1927 Chiang instigated a campaign to exterminate the communists. The opposition to this bloody attack became known as the Guangzhou Uprising, and this statue memorializes the five thousand victims.

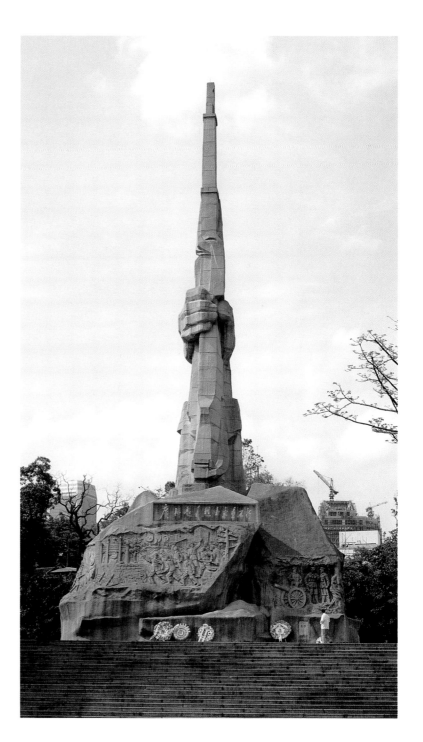

Guangzhou Liberation Monument. *Pan He and Lian Mingcheng. Granite; 1980; Guangzhou*

This monument celebrates the Communist liberation of the city from the Nationalists on October 14, 1949.

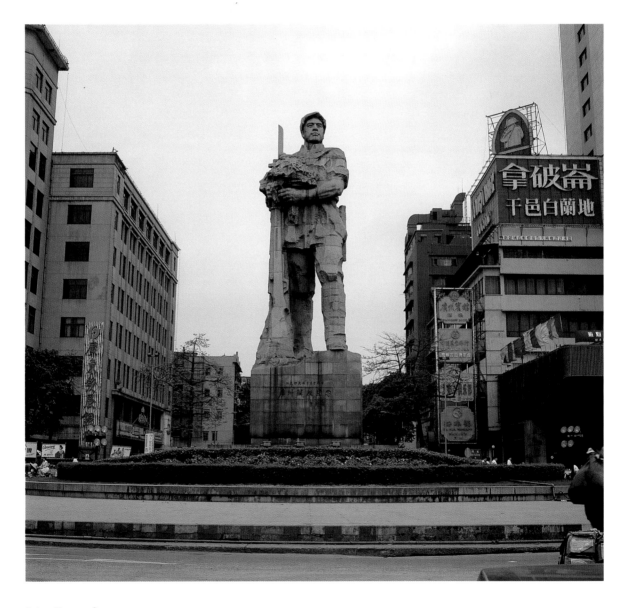

During the Warring Era. *Li Hanyi. Granite; 1987; Guangzhou People's Park*

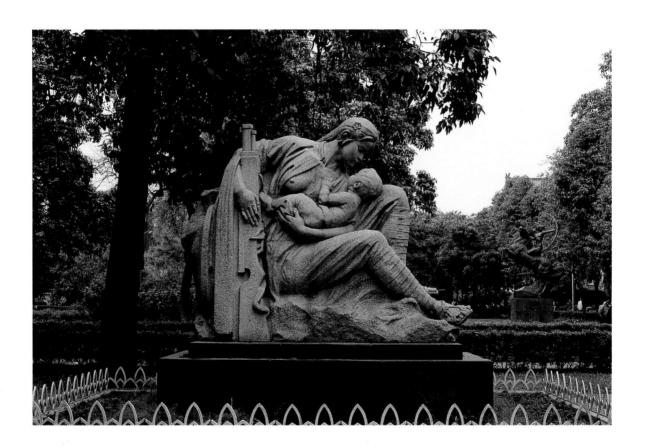

Zhuhai

Zhuhai Revolution History Memorial. *Pan He, director, with the Guangzhou Fine Arts Academy faculty. Cast concrete; 1980; Zhuhai*

Pan He was the lead artist of this large collaborative relief project built into a mountainside. Discussing the passion of the team that built this massive relief carving, he told us that their energy level was so high that they finished in only three months. They shared a real spirit of collaboration and belief. We discussed how the unique passion of that era is no longer part of Pan's own work. He is not interested in doing collaborative projects, and he feels that the younger generation of artists does not understand the collaborative spirit. He appeared to be deeply moved by the memory of this spirit and saddened by the lack of it in the next generation.

Pan spoke about some of the challenges of collaboration: "It is always more intensely negative than positive. Working with Lian

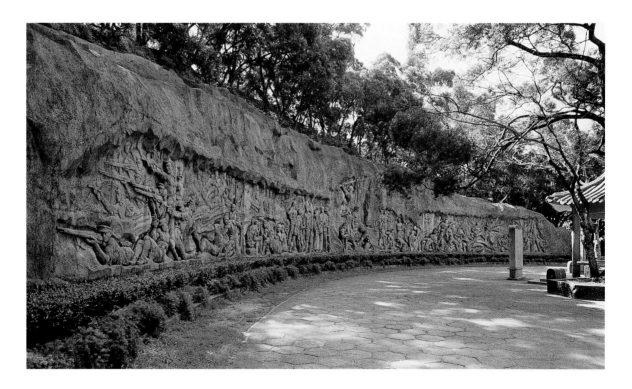

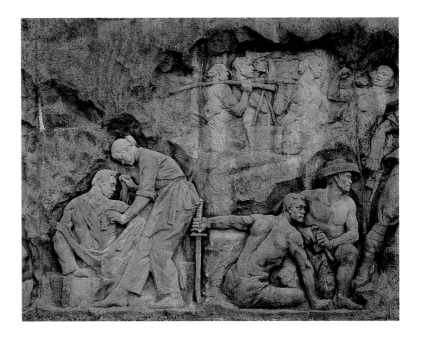

Mingcheng is better because he was my former student. We get along well because I can be more stubborn! If the relationship is equal, then it's more negative." In the early days, in order to spread the wealth, Pan He solicited other artists to work with him when he received projects. There were not many projects available, and he wanted to prevent jealousy since he received most of them. "In recent years," he said, "there are lots of projects going on, so everyone has work to do. Now I prefer not doing collaborative work."

Summing up his fifty-year career, this energetic, always self-critical seventy-year-old stated, "I don't really have any good works. When I look back at all of my pieces, I always feel there's something not quite right. I have to agree with whoever said that sculpture is the art of regret, of pity—there's always something that should have been done better. Unlike in the United States, here every piece we ever did was done in a hurry. The government always gave us a deadline and a certain range of subject matter. Rushed freedom has a kind of limitation—you can't jump too far."

The Goddess of Zhuhai. *Pan He.*
Granite; 1980; Zhuhai

In 1980 Zhuhai, along the coast of southeast China, was a quiet, small town near Macao and Hong Kong. Its beautiful terrain and location made it ideal for a beachside resort community. Pan He had the foresight to propose to the city fathers that the future development needed a landmark symbol. He created his own myth of a fishing goddess, which he pretended was part of the legendary history of the region, and convinced the city government to commis-

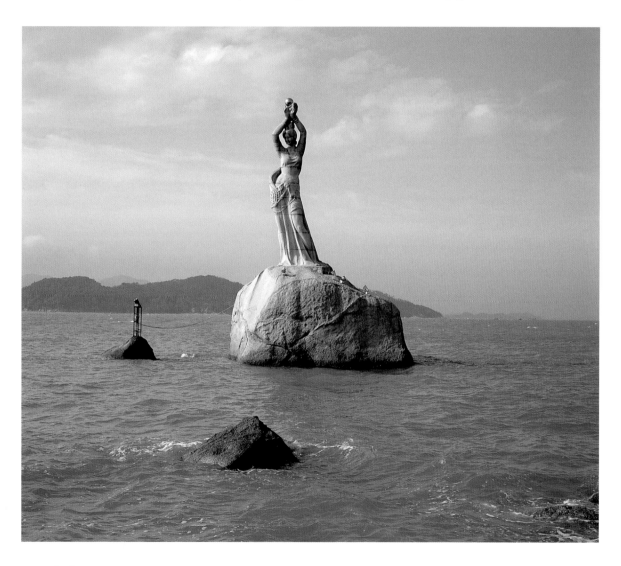

sion this lovely granite figure. Its sensuousness is derived from ancient Indian figures. The work was remarkably popular with the public, and today is considered the symbol for this bustling coastal city, appearing on all of the brochures advertising the resort community.

"My province, Guangdong," Pan He stated, "was the first to be opened after the Cultural Revolution to foreign countries and investors. Once it was opened, I used the opportunity to go to the city government of Guangzhou, the local government, the district office, and the people's representatives to let them know that we had to improve our situation to provide the right environment for foreign investment. We needed to create beauty for the region. I don't have money, I don't have power, but if I convince someone who has money, then I have money. If I convince someone who has power, then I have power, like the early twentieth-century writer Lu Xun—that was his philosophy. So I tried to create a system that supported art, not only for myself but for all Guangdong artists and the public. If it was just for me, then I wouldn't get help from society. This was to be for artists, society, and the future of the country. Being a beggar does not work here. But if I say, 'I'll help improve this city,' that will work. It was very difficult to convince the city to do this. I had to convince the mayor, not the vice-mayor. If I could convince him, then he would use me and I would use him. I thought, 'If I'm rejected, don't stop. Keep doing it.' In China artists not only have to know how to do their art, but they have to know public relations, how to overcome dealings with bureaucrats, and how to get into the system.

"So now the mayors of Zhuhai and Shenzhen are my friends. I've known four generations of mayors. The first one had lots of power; then when his term expired, I grabbed the next, and then the next. I always make sure that he has an art administrator on his staff to beautify the city and create new projects. Since those early days, we've created over one hundred projects."

Shenzhen

This dramatic sculpture was created by a young professor at the Sichuan Fine Arts Academy in Chongqing. At first, his plans for mounting the two bronze elements on the structural members of this skyscraper were rejected by the architect and the engineer of the building. Using his own money, he then hired an engineer to find a way to convince the others that the work was feasible. As a result, he was able to create this work, which gives the illusion that the Ocean God is riding his chariot through the building.

Ocean God. *He Liping. Bronze; 1994; Shenzhen*

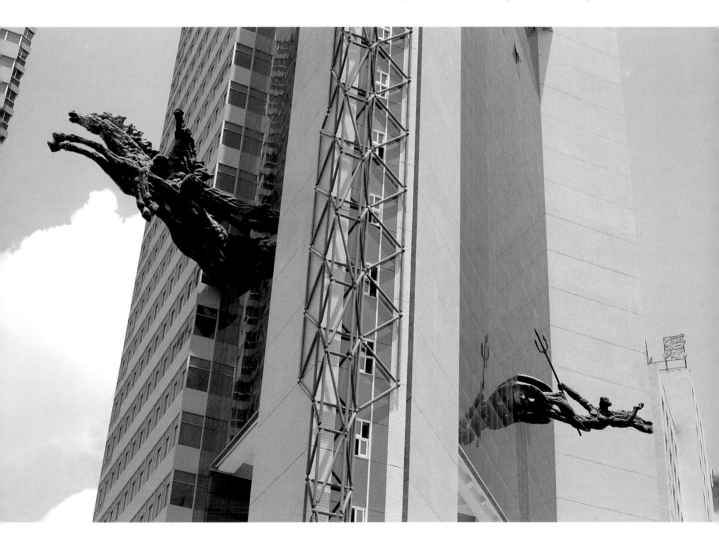

Hard Times. *Pan He. Bronze; 1984 enlargement of the original 1957 version (currently in the collection of the People's Liberation Army Military Museum, Beijing); City Hall, Shenzhen*

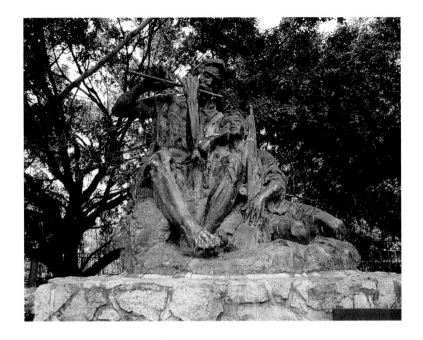

This is one of Pan He's earliest pieces, commissioned by the Communist Party. He was asked to produce a sculpture that portrayed the triumphant heroism of the People's Liberation Army in the battle over Hainan Island. But Pan decided he did not want to follow the typical treatment of such a subject in art of the early 1950s. Instead, he portrayed two soldiers at the end of their physical strength, starving and ragged, sitting down for a moment of rest between battles and playing the flute. Their spirits are still high, despite their condition. This is the quality that appealed to those who had commissioned the work, and ultimately Pan's poetic portrayal of these soldiers' plight became very popular with the people.

Asked why he thought this work had been successful, Pan replied, "I like work that has stress in it—anguish. Because of something in my personality, 'victory' never has drawn my attention— only hardship. I am always excited by those wonderful tragic moments. I like tragedy. I'm not interested in victory, which floats there without any weight at all.

"The piece depicts a guerrilla war troop under Communist leadership. They originally had eight thousand troops fighting on Hainan. All but twenty-three were killed. So this depicts the hardest time of that war. They're taking a break during a lull in the fighting, and the old guy is starving, so thin, but they keep up their spirits about the revolution. They play the flute and still have faith in the future and in what they're doing. All of the Chinese, including me, had that kind of faith to support us during those hard times."

It occurred to me that Pan had also intended to show the soldiers doing their best to escape the ravages of war and turning to art for a momentary reprieve from battle. Many of his works have similar subtle layers of meaning, which appear to have flown over the heads of some of the commissioning bureaucrats. When I suggested this to him, he responded, delighted, "Yes, it's true! It's like riding a bicycle—a balancing act. In China you have to adapt to situations to be able to survive, and you have to be really flexible. If you don't care, no one else cares. But if you're too flexible, too adaptable, you won't survive. You give up your own personality as a human being. It's like tai chi—you avoid the fist as it comes at you, and then follow the movement to pull the attacker over."

Young Ox (*also known as* **Bull Reclaiming Wasteland . . . Pulling Up the Roof of Poverty**). *Pan He. Bronze; 1984; Shenzhen City Hall*

This strong ox is intended to serve as a reminder to Shenzhen city bureaucrats to work hard for the people. Deng Xiaoping was so impressed with the work that he attended the unveiling and hosted the dedication ceremony.

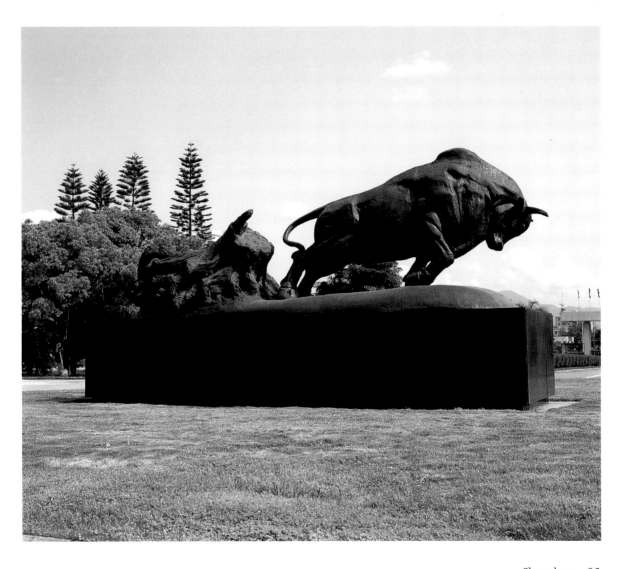

Electronic World. *Zhan Wang. Stainless steel and bronze; 1993; Shenzhen Electric Building*

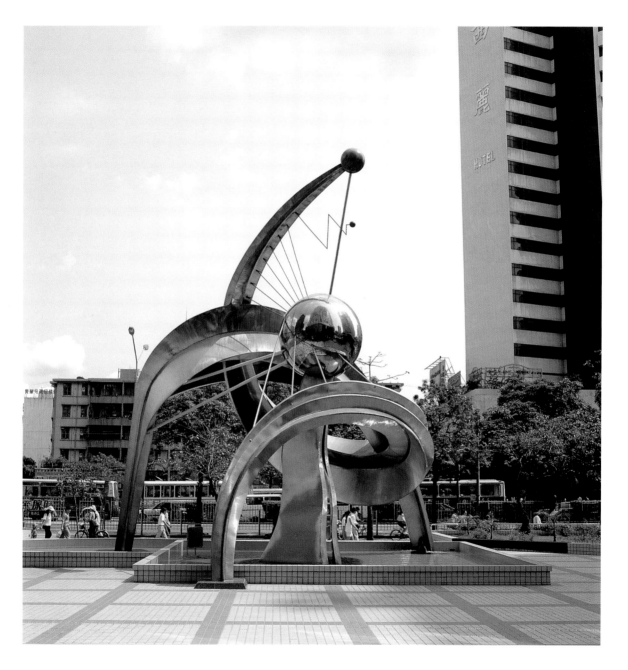

Chengdu

Dance. *Ye Yushan. Bronze; 1984; Chengdu Symphony Hall*

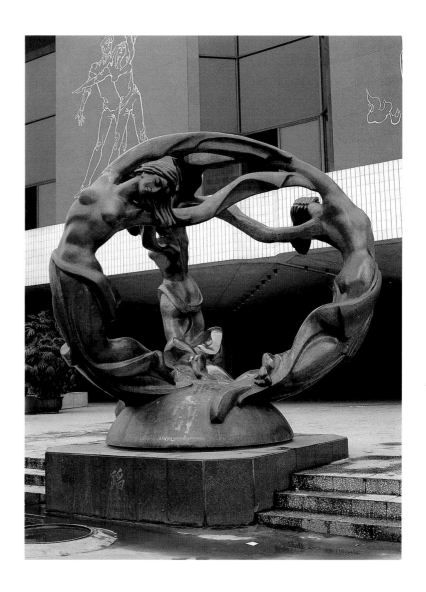

The Traces of Chinese Dance.

Jiang Bibo. Gold inlay relief; 1984;
Chengdu Symphony Hall

Gold inlay relief on exterior architecture is becoming more common in public projects throughout China. Pan He and Jiang Bibo are two of the early contemporary pioneers of this technique.
In this work, Jiang Bibo has illustrated the major movements in Chinese dance throughout the ages.

Mao Zedong. *Long Deihui, Guo Qixiang, et al.. Marble; 1969; South People's Square, Chengdu*

This Mao statue, the largest ever created in China, stands 12.26 meters tall. The artists chose this height because Mao was born in December, the twelfth month, on the twenty-sixth day. Mao is depicted in the traditional position, with all five fingers of one hand outstretched and raised above his head. I was told by several artists that the public is said to have interpreted this gesture as meaning, "You must serve five years in the countryside." The other hand, partially hidden behind the figure's back, with three fingers outstretched, was interpreted as, "Plus three more years!" In 1995, when this photograph was taken, the surrounding buildings were covered with billboards advertising, in a dramatic capitalist manner, such items as refrigerators, liquor, and nightclubs.

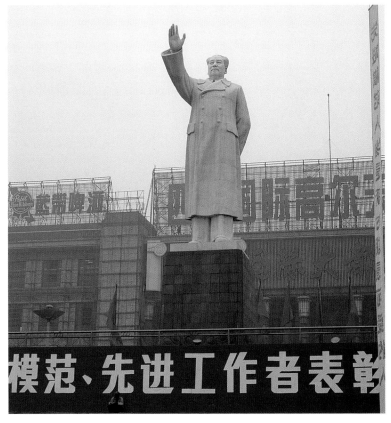

Construction Workers. *Ren Yibei. Stainless steel; 1985; Chengdu*

Although this is a fairly typical social realist piece, intended to cele-
brate the workers of society, the public had an interesting reaction
to it. Since the figures are positioned on a giant circular support
structure, it was said to express the sentiment "Workers equal zero
in China!"

February 16th Martyrs Monument. *Zhu Changxi.*
Fabricated bronze; 1990; Chengdu

On February 16th, 1928, thirteen students and a dean affiliated with Chengdu Normal University who were Communist supporters were executed by order of local warlords and Nationalists. The victims had participated in organized protests—over workers' wages, educational funding, and currency stabilization—that resulted in the beating death of a prominent school principal appointed by the local warlord, a Nationalist sympathizer.

Opening the Mountain. *Tan Yun. Bronze; 1991; No. 1 Circle Highway, Chengdu*

Rainbow. *Tan Yun. Stainless steel; 1990; Sports Coliseum, Chengdu*

Small versions of this sculpture were originally commissioned to be used as trophies in the Asian Games held in Beijing in 1990. The larger version was developed later for Chengdu, Tan Yun's hometown.

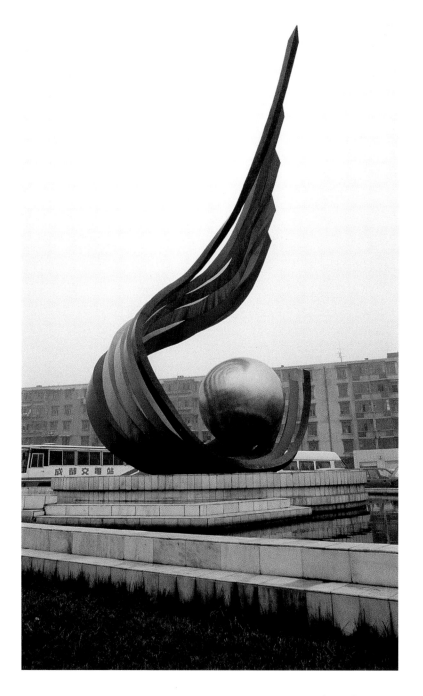

Untitled. *Tan Yun. Stainless steel; 1992; Chengdu*

Placed in front of the *Sichuan Daily* newspaper publishing plant, this work represents pages of the newspaper flying to all corners of the country.

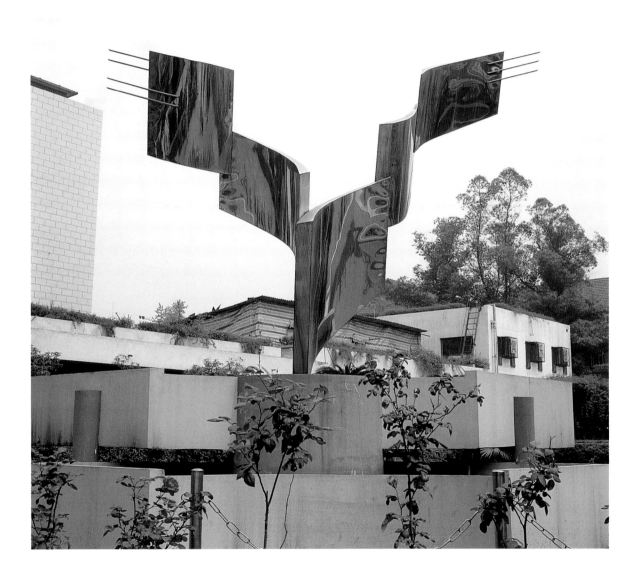

Peace. *Tan Yun, Wu Haiying, Xu Baozhong. Stainless steel; 1987; Sheep Market Street, Chengdu*

This work is unusual in its integration into an overpass bridge structure.

Xindu

White Dragon Gate. *Zhou Cheng. Stone; 1994; Xindu*

This traffic island gate features 108 dragons.

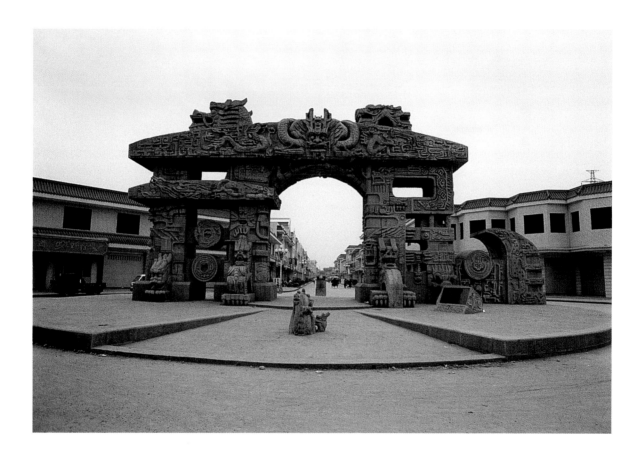

Deyang

Stone Ox Gate. *Ye Yushan. Granite; 1992; Tai Shan Road, Deyang*

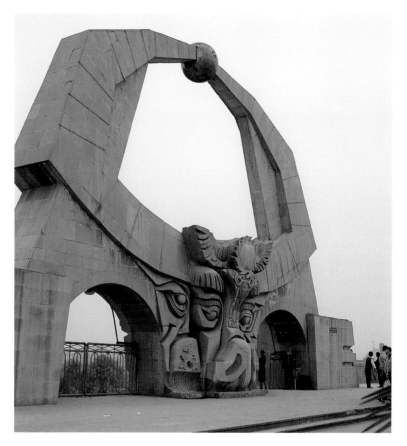

Light of Wisdom. *Zhou Cheng. Granite; 1992; Tai Shan Road, Deyang*

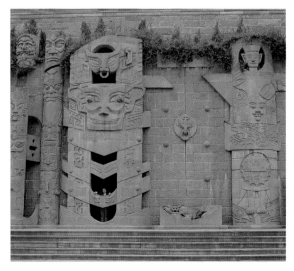

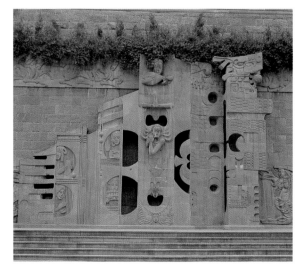

Song of Life. *He Douling. Granite;* *1992; Tai Shan Road, Deyang*

Public art in China is being integrated into civic works projects. Like recent "design teams" in the United States composed of artists, architects, and engineers working together on a particular civic project, contemporary Chinese artists work in subway tunnels, in airports, on sports domes, and on highway projects. One of the most intriguing projects of this kind is in Deyang, near Chengdu. Deyang is the birthplace of Ye Yushan. Ye described for us the genesis of this project: "The mayor of this city, Zhang Renlian, is a visionary man. First of all, unlike many of our peasant bureaucrats,

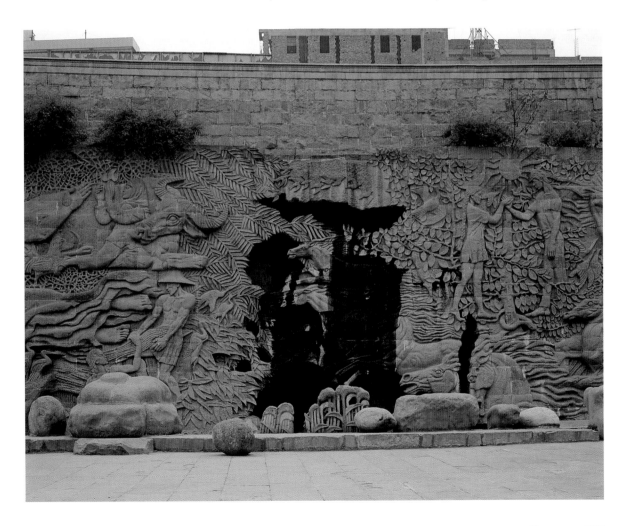

he is well educated and has an industrial engineering background. He is also very open-minded. To widen Tai Shan Road, city engineers needed to create a quarter-mile long retaining wall that would require massive quantities of fill dirt, which would be very costly. It was decided instead to make archways and spaces under the road, where shops and restaurants could be created. This was a brilliant idea because they gained thousands of square feet of architectural space and saved twenty thousand cubic meters of fill dirt! Since arches require columns, Mayor Zhang suggested creating traditional Chinese dragon reliefs on them. He also came up with the idea of creating art on two blank walls. This is the mark of a man with a cultural education. So he gave us the 'frame' within which to work. Traditional folk artists carved thirty-five dragon columns. I was asked to create the gate entry on top of the retaining wall, and Zhou Cheng was asked to do the reliefs on the walls. Since it was such a large project, Zhou invited He Douling to work with him.

"Mayor Zhang let the artists decide what subject matter they wished to incorporate. I chose to create *Stone Ox Gate* because there is a legend of a stone ox that was used to mark the level of the river that runs through this region. Also, in China we worship the spirit of the ox."

Zhou described the choice of subject matter on the retaining walls: "Deyang is an industrial city, so we first discussed the idea of including images of freeways and factories, but there was some opposition to this. Many said they did not want more industrial imagery—the city was already too industrial. So we decided to look back to nature and the origins of life. He Douling's relief incorporates water flowing out of the wall—it's a unique fountain. The themes of this relief are the seasons; mother and son; man and woman; and natural elements. It's about the connection between humans and nature, and it's called *Song of Life*.

"He Douling was able to develop his idea as the engineers developed the plans for the wall, working his design in with the archi-

tecture. My wall was already completed, so I had to add elements. I asked the engineers if I could dig out sections of the wall and penetrate into it, but they said no, that it was bad luck to tear into a new wall!

"For my section, *Light of Wisdom*, I developed an idea using architectural elements. I call this style 'concentrated architecture and expanded painting.' The relief is very high, in some places as deep as five feet, making it interactive. Most art in China says, 'Keep off.' Not this relief. Steps were even constructed to encourage people to climb inside. This way, they can touch the stone and feel its spirit. The width of the relief—more than fifty meters—creates a sense of time that is controlled to some degree by the artwork. The fact that it takes a long time for the audience to walk along it, and that it is at ground level, results in lots of interaction. This is very different from the audience experience around a discrete three-dimensional object."

These two reliefs and *Stone Ox Gate* define one side of a large, open park created below the highway. The project took over three years to complete and employed more than three hundred stone carvers. Well respected by both the art community and the construction/engineering community, it is known throughout China as "Another Great Wall."

There were, however, some problems with the project. Zhang Renlian retired before it was completed. After the professional artists were finished with their assigned sections, a considerable amount of wall remained blank. Some of the bureaucrats of Deyang felt that no more money should be spent on art. Others were willing to incorporate more art, but not at the fees charged by professional designers and sculptors. Finally they decided to continue the work, but rather than hiring a professional designer to integrate the new design with the existing part of the wall and professional sculptors to carve it, the bureaucrats employed folk artists at a much cheaper rate, with correspondingly poor results.

Chongqing

Winter. *Ye Yushan and Wu Mingwan.*
Aluminum; 1984; Yangzi River Bridge,
Chongqing

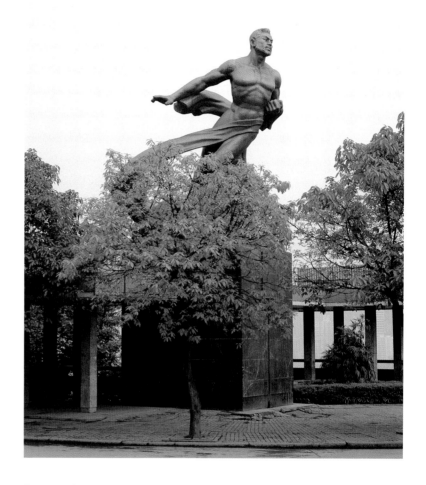

"Right after the Thought Liberation Conference of 1979, I felt really liberated," I was told by Ye Yushan, former director of the renowned Sichuan Fine Arts Academy and now a representative in the National People's Congress from Sichuan Province. "So I proposed four figurative nudes, to adorn the ends of the Yangzi River Bridge in Chongqing. For this large project over this great river, I believed the nude was the most beautiful form in nature. There were no nudes in public art then. So that was my own thought liberation and art expression. I didn't do soldiers, workers, or peasants. But it's a pity. They forced me to add a thin layer of clothing on my proposal

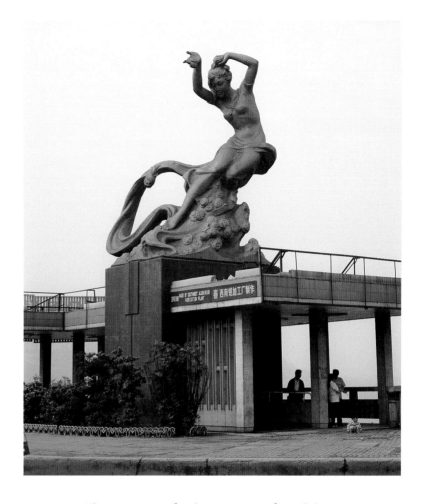

Spring. *Ye Yushan. Aluminum; 1984;*
Yangzi River Bridge, Chongqing

maquettes. The governor of Sichuan wrote a formal document
stating that nude figures were inappropriate for the bridge, and
I believe it was actually the first time in China that formal,
specifically written documentation was used to censor art.
There was nothing I could do except make the changes—otherwise
the entire project would not have been realized. I did my best to
keep the lines of the figures' bodies, however." In the 1990s Ye has
been able to execute numerous nude figurative commissions in
prominent public locations, and they are highly respected by
contemporary officials.

Monument to the Martyrs of Gele Mountain. *Ye Yushan and Jiang Bibo.*
Granite; 1986; Gele Mountain, near Chongqing

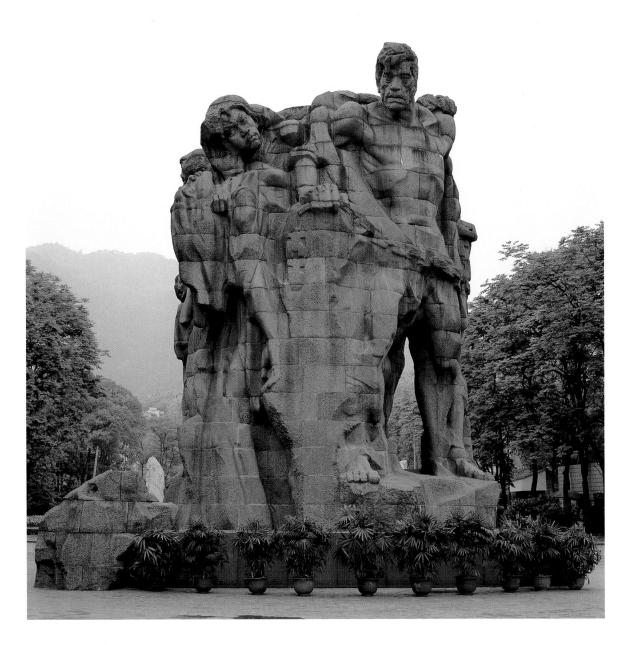

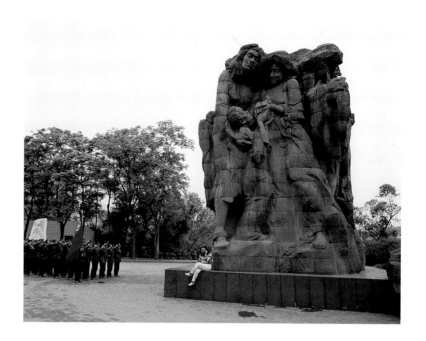

Probably the most poignant piece of public art by Ye Yushan is this martyrs' memorial (two sides of which are shown here), done in collaboration with Jiang Bibo. Social realist works of this type, memorializing Communists who died or suffered while fighting for the revolution, are abundant throughout China. Figures in chains, blindfolded, or carrying the dead or dying are typical themes of this genre. Many of these contemporary images refer back to ancient legends. Grand in scale and dramatic in configuration, such works are powerful and effective reminders to the public of the huge sacrifices that were made to accomplish the revolution. Gele Mountain is also the subject of *Xiao Luobutou* (see p. 11). On the day of my visit the People's Liberation Army was conducting an indoctrination and initiation exercise with a troop of new cadets. An army troop saluted the monument while Ye Yushan's friend Chong Hua, perched on its base, chatted long distance on her cellular phone. For me, this photograph, perhaps my favorite of all those taken on my trip, captures contemporary China.

Flying. Yu Zhiqiang. *Stainless steel; 1992; Chongqing*

Some of the abstract pieces I saw were quite handsome, particularly this work by the quiet and unassuming forty-year-old Yu Zhiqiang, a professor at the Sichuan Fine Arts Academy in Chongqing. His works were well fabricated, too, which was not always the case. Throughout the country, many artists complained about the poor level of fabrication assistance available.

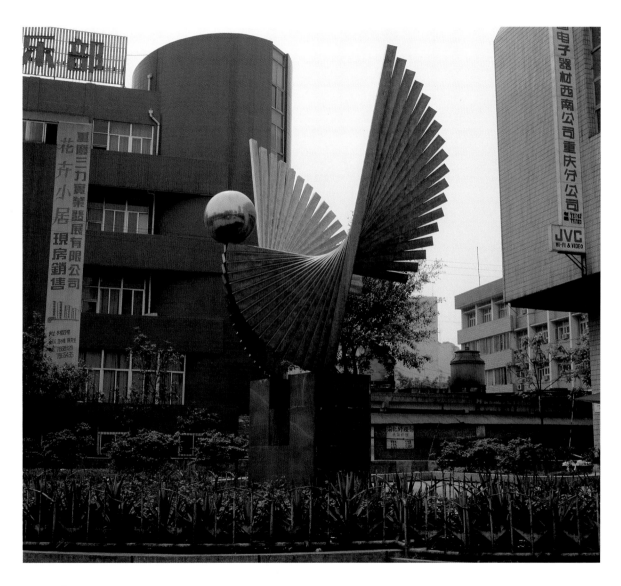

Xi'an

Emperor Qin Unifying China. *Wang Tianren, Meng Xiling, Ge Demao. Granite; 1993; Xi'an*

This giant monument is located on the route between the city of Xi'an and the excavated third-century-B.C.E. tombs containing the world-famous terra-cotta warriors commissioned by the first emperor of the Qin dynasty. This piece commemorates the emperor's quest to unify China under his rule and depicts him at the beginning of his crusade, surrounded by his soldiers and aides. The work is over three hundred feet long, and the sculptors employed over one hundred stone carvers for several years to fabricate the monument.

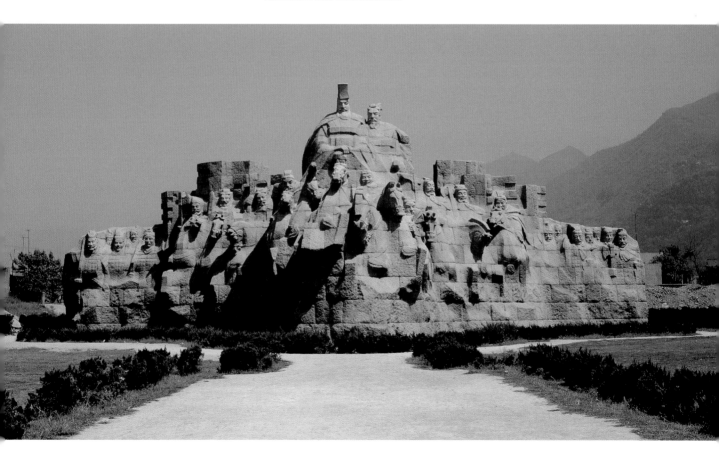

Li Bai. *Anonymous. Date unknown; marble; Xi'an*

The famous Tang dynasty poet Li Bai (Li Po) believed he needed to drink alcohol in order to be inspired. This artist has attempted to capture the contrast between the drunkenness of his body and the clarity of his artistic mind.

Silk Road. *Ma Gaihu et al. Granite; 1987; Xi'an*

This massive sculpture marks the Chinese end of the famous
Silk Road used by Marco Polo and other explorers and traders.

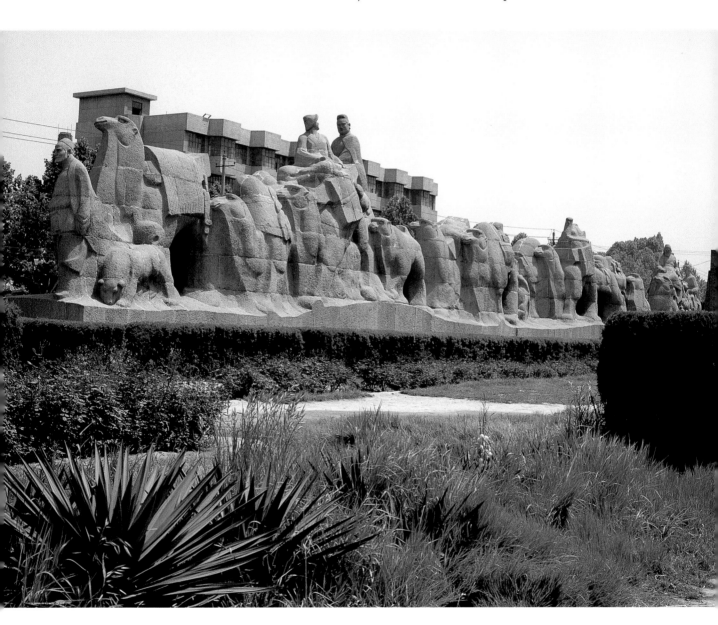

Mudanjiang

Monument to Eight Heroines Diving into the River. *Yu Jingyuan, Zhang Dehua, Cao Chunsheng, Situ Zhaoguang, Sun Jiabo. Granite; 1988; Mudanjiang (photograph by Cao Chunsheng)*

This huge public artwork depicts eight women, carrying children and wounded adults, choosing death by drowning over surrender to the Japanese. This true story echoes the legend of a similar incident over a thousand years ago.

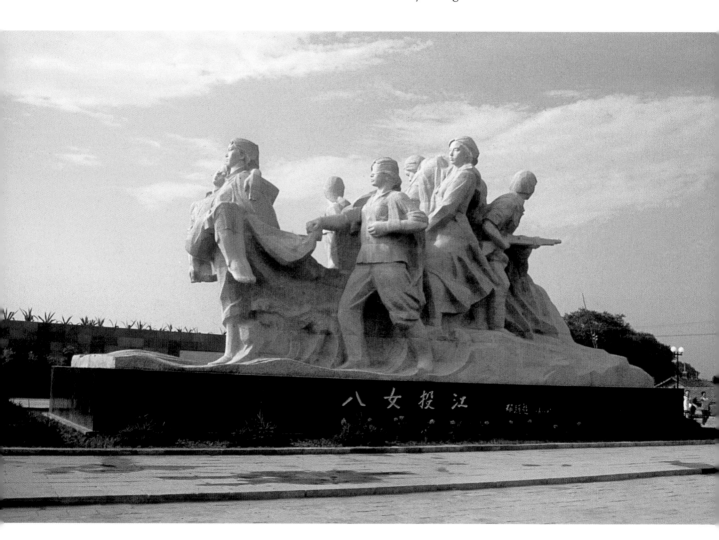

八女投江

Weihai

Located near the coast, this park contains many outdoor sculptures by artists from around the world.

Fu Zhongwang, assistant professor at the Hubei Fine Arts Academy in Wuhan, is an adventurous, already well-known artist in his late thirties who has collaborated on many of the largest public projects in Hubei Province. His studio work in stone and wood timbers, in contrast to his public projects, is unusual among Chinese sculptors in its exploration of the textural and structural characteristics of the materials he uses and is a notable exception to the propensity of his countrymen to work with imagery in abstract pieces.

Notch Structure. *Fu Zhongwang.*
Granite; 1993; Weihai Park
(photograph by Fu Zhongwang)

Nagasaki, Japan

Peace. *Pan He, Wang Keqing, Guo Qixiang, Cheng Yunxian. Marble; 1986; fabricated in Beijing, installed in World Peace Park, Nagasaki, Japan (photograph by Cheng Yunxian)*

Wang Keqing, one of the four artists invited to collaborate on this work, described the process used to create it: "In 1985, at the request of the mayor of Nagasaki, Chinese leader Hu Yaobang agreed to contribute a statue entitled '*Peace Girl*' to the World Peace Park, located on the site where the atomic bomb was dropped. The government assigned four senior artists in China to work collaboratively on this gift. Even though the Japanese government brought disaster to the Chinese people, the Japanese people still love peace. So our government asked us to do this and allowed us artists to determine the exact theme. The four of us made many maquettes, which we submitted to the Communist Party's Central Committee for their opinions.

"We picked out the best maquettes by each person and then narrowed those forty to fifty down to less than ten. Then each artist picked one of his own maquettes. Each thought his own piece was best! Then we listened to the opinion of the whole group. We discussed all aspects of each design and picked the best two from the four maquettes, which we made into larger models. After we were done with the big maquettes, we sent them to the national leaders on the Central Committee to get their opinion. But they wanted the artists' opinion. We had discussed before which of the two proposals we favored, and the Central Committee agreed with our first choice.

"The entire project took half a year. The piece is three meters high. In the process of creation, we had to take advantage of our specific talents, develop a personality for the subject of the piece, and incorporate the collaborative spirit. It's really hard to work this way. The cooperation among the four sculptors in collectively creating the statue was a very complicated and interesting process. Because each has his unique artistic character and style, one plus one does not necessarily equal two in terms of collective cooperation. If the collaboration is good, then four may generate the efficiency of four or even six people. But if the cooperation is bad, they

will barely produce the work of two or even one and a half people. In this project, the four sculptors cooperated with one another in a well-coordinated manner, respected one another, and complemented each other in terms of artistic skills. Consequently, we were able to fully integrate the artistic talent of each with the collective wisdom of all in reaching the ideal state of artistic creation.

"When we started the piece, we had to divide up the work. Pan He worked on the head, for example. I worked on the folds of cloth, the hands, and the feet. As we developed the final full-scale maquette, we discussed ways to improve it, commenting on each other's work. Because we were all old friends, we got along really well. We made many adjustments. The final maquette was made in clay, then cast into plaster. The stone carvers used the final plaster for their reference. Assistants roughed out the stone from eleven blocks of marble. Then the sections were placed together on site in Japan, and we artists put on the finishing touches ourselves, spending about three weeks on site." Ultimately, *"Peace Girl"* has been greatly valued by the Japanese people, who call it a Chinese peace envoy.

Public Art and Artists

The Arts Academies

The effects of China's government-sponsored art academies and art institutes are profound. The academies are much like college-level art schools in the United States, where students and professors are involved in the learning and practice of all of the arts. The arts institutes, however, also sponsored by the government, are not teaching environments but rigorously selected groups of practicing professionals who maintain active studios in their disciplines. Along with professors in the academies, these artists in public art/sculpture institutes make up the pool of professionals chosen to complete large-scale public commissions. Members of the art institutes, as well as the academies, hold the title "professor." An artist not affiliated with either institution is unlikely to be considered for a large commission. In fact, it is through these institutions that the Chinese artist becomes officially certified and formally licensed to execute public artworks. This system has both advantages and disadvantages. On the one hand, it creates a highly qualified, competent, and tightly knit group of like-minded artists who can easily collaborate in an effective way. This body of artists is respected by the government. On the other hand, there is a danger of inbreeding and exclusivity. What becomes of a young, adventurous artist if all the positions in the academies and institutes are filled?

Zhang Yonghao addressed this issue: "In the art schools there is definitely this kind of problem, but it's changing. The education and training of students and professionals serves this society, but if the

society discovers that they are not the right people, qualified to serve in the right way, then we will respond and change this direction."

Pan He also spoke of this situation in Guangzhou: "Right now, young artists are definitely doing lots of public art in the cities. There are no specific programs to improve the situation to promote young artists, and it's true that the most important projects almost always go to the older, more established artists. But some of the smaller projects that the older artists don't have time for are going to the younger artists. They're picking up private commissions, too, and making connections of their own."

Artists in Government

Since the 1980s a curious phenomenon has occurred in the politics of public art in China. Artists have gained tremendous power and are now an important force that instructs the government on choices of subject matter, site, and the selection process. Government officials, who are usually untrained in art, rely on professional artists to determine the best ways to realize projects. Some artists are beginning to hold officially sanctioned government positions as "Art Representatives," who report to the government on the public art needs of their communities. Often a community will request that a public monument honoring a hero, martyr, renowned intellectual, poet, or historic event be created for their neighborhood. The Art Representative relays the community's request to the local government, with the hope that the idea will be endorsed and funded. Since major cities and many provincial governments have budgets for the yearly acquisition of public monuments, good ideas for projects generally are approved. An art committee is established, or an existing art committee, common in the large cities, acts with artists, professional art managers, and architects. This group determines the exact theme of a project, whether it should be figurative or an abstract symbol, what site in the community is appropriate, and how

to select the artist or artists to execute the project. Many of the finest artists from the community serve on these committees, making for some intriguing maneuvering, since no barrier prevents those serving on the selection committee from being chosen to do the work.

Galleries and Criticism

A significant factor affecting public art in China is the infancy of its contemporary art museum and gallery system and relatively few well-trained art critics versed in current international trends and movements. Until very recently there were no commercial art galleries as we know them in the West, and there was very little flow of information into China regarding the international art world. The effects of this isolation are double-edged. The fact that artists serve also as critics empowers them. Now that international art magazines are slowly entering the country, however, and exchanges are beginning to occur, there is a tendency in some Chinese contemporary sculpture, especially that of younger artists, to visually echo trends seen in the magazines coming from the United States and Europe. Unfortunately, these works tend to copy the stylistic visual aesthetics of international art without the corresponding theoretical inspiration and analysis, making for very shallow work. This problem is partially a result of the language barrier, since Western languages are not commonly understood by artists in China. The situation is changing rapidly throughout the entire culture, however, and eventually the art community, along with the rest of the country, will realize and actively seek the economic and intellectual benefits of international communications. The present situation is characterized by the creation of a great deal of abstract sculpture, highly touted by artists and by the very few critics, which is reminiscent of the work done in the United States thirty years ago. If there were more trained and knowledgeable critics, more museums showing the

best of the world's art, more exchange programs bringing international artists into China, and more contemporary galleries showing the "cutting edge," this situation would improve. China's public artists would be pushed along faster and would catch up to the rest of the world in this area of artistic creation. Many of the artists I interviewed wanted to see this happen sooner rather than later.

Privately Funded Public Commissions: A New Paradigm

As the economic situation in China begins to resemble that of the West, collaborative projects continue to occur regularly, but government-funded public projects are sometimes given to individual artists who are paid for their efforts, although not lucratively. Recently many artists have for the first time received private commissions, as private corporations (both Chinese and international) build skyscraper office spaces and modern international-style hotels in major cities. Like their international counterparts, Chinese corporations and hotels require art as part of the expected environment. For these endeavors, the Chinese contemporary public artist is paid handsomely, and, as a result, there is a new competitive spirit forming in the art world.

Occassionally there is a bit of corruption in the artist-selection process and in deciding how the artwork will be fabricated. Sometimes "middlemen" buy ideas and sketches from artists and represent these sketches as their own in order to get the commission to fabricate the work. Such middlemen might not even buy the ideas from the artist, but simply put a famous artist's name on their own sketches and falsely claim to represent that artist. This practice is obviously distressing to most of the artists, but has yet to be resolved.

Pan He shed some light on this complex situation: "This is the price of opening the market. Before, I was really angry about this, but we always say, 'When you go forward, there is something that

goes backward.' We'll need laws to regulate copyright, but it'll be difficult. That's why businessmen like doing business in China— there is no control. When I went to Hainan Island to jury a competition, there were many designs that were just signed with the names of companies. No artists' names. So I asked who were the artists who designed those maquettes. They couldn't tell me. I didn't pick the ones like that. Lots of my own work has been copied, and I have no protection. I have nothing to do with this, and I don't have the energy to take care of it, to deal with the lawyers."

Other new sources of patronage are private collectors, especially from Hong Kong and Japan. Unique collections are taking shape outside of China, put together by shrewd collectors who know that many of the older, extremely talented figurative sculptors, who were trained in Europe in the 1930s and 1940s, will soon retire. For the most part, it seems that contemporary artists are enjoying private patronage. Comparing government commissions to those done privately, Ye Yushan represented the sentiments of the majority of his colleagues: "Private commissions are more pleasant, more relaxing. I have more freedom to really use my imagination. The private patrons always trust me. With the government, there are too many bureaucrats. And those bureaucrats often don't understand art, but they will always give you many suggestions."

Women Public Artists

In China's extremely male-dominated culture, there are a few prominent women sculptors (although certainly not as many in number or percentage as in the United States). To my surprise, none of the women public artists I spoke to felt discriminated against, excluded, or held back by the government or the art committees on account of gender, although they all felt sexism in the general culture. It is likely, of course, that they did not want to share negative perceptions with an American male artist. In any case, women have

executed some of the most highly prized works in the country, such as the gold inlay relief works portraying the history of Chinese dance on the walls of the Chengdu Symphony Hall by Jiang Bibo (p. 96) and the carvings and bronzes by Wu Huiming. One of Wu's sculptures recently received an honor none of her male counterparts has yet achieved: prominent display in front of the United Nations Building in New York City. I learned from a couple of the women sculpture students in Du Takai's Public Art Program at the Central Academy of Art and Design that they had "never even thought about gender discrimination." They liked working in large scale, so they just did it.

In her apartment in Shanghai, Wu Huiming spoke openly about the challenges she has faced: "When I have to go talk to business-men at a company to do a commission, my first appearance does not create a good situation. I'm small, I'm a woman, and I don't look like a sculptor. So they doubt. There's a hesitation as to whether I can do the job. After they learn about me and understand the nature of my work, there's no problem. But in the beginning, if they don't know me, based on first appearances, I'm in a really weak spot compared to an older man who looks like a sculptor."

Maintenance

One of the most challenging issues facing public art in China is maintenance. In every city I saw examples of severely neglected works that were rusting, peeling, and collapsing. In some instances, sections of bronze pieces had been severed from their sculptures, presumably to be sold by vandals as scrap metal. Very little funding is allocated by the government and art committees for maintaining and repairing public artworks, and in a society where so many people are impoverished and also uneducated about art, such vandalism is inevitable. Many public artists have designed their works with vandals in mind; they place them out of reach on high

pedestals or in traffic circles, where access is almost impossible because of the constant heavy traffic.

Conclusion

Du Takai, a colleague of Yuan Yunfu and professor of sculpture and public art at the Central Academy of Design and Fine Arts in Beijing, described China's recent period of economic growth: "Before, the economy was really slow. When the economy does not go forward, public art does not go forward. From 1979 to the present [1995] is the fastest growing period in Chinese economic history. The scale of our cities is expanding. Some of our cities appear to be exploding. And new cities are being created instantly. We can tell that this development will proceed even faster in the future, so this is a great opportunity for public art. For historical reasons, public art is still in a stage of development during this short period of time. Our public art must develop rapidly. Public art will have an important role in people's lives in the future of China, and it will create greater awareness in the minds of the Chinese people." That day I had the honor of viewing and discussing proposals created by Du, by a few of his younger colleagues, and by a dozen of his advanced students for large projects to be created in a nearby coastal city. Some of the most progressive-minded sculpture proposals in China today are coming out of his studio and classroom.

Zhang Yonghao also provided an excellent overview: "In the early twentieth century, sculptors like myself were influenced by Western art because our professors studied in Europe. But later we realized that Western art doesn't always work in this country. [After the Cultural Revolution] we began to realize more about our own culture and heritage. Western art has its own beauty, but Eastern art has its own beauty, too. And we want to combine these to serve our people. We researched the ancient Dazu stone carvings and those at Maoling, looking for our roots. Since China has been more

open in recent years, we felt we could communicate between East and West. Art is the way to communicate in the future, to further communication.

"How to beautify this country is the challenge now facing us in art and sculpture. The state of our environment, compared to that of the United States and Europe, is shocking. It's a big problem. We must create harmony with the environment and develop our sense of rich culture in our cities. How to improve our sculpture, and the questions surrounding varieties of expression in art, are in the forefront. Art should give people a sense of beauty, but you cannot let the people 'eat only bananas'—they should have different types of fruit. As the economic situation here opens, to improve our art we need to foster different tastes among the people. The only thing we're afraid of is that our art won't be able to satisfy the demands of our society. Of course we can't compare right now with the United States or European countries in terms of public art. But we're doing our job, improving, and we hope that in the future we'll see great change in sculpture, the environment, and the architecture of our cities. Now is the most exciting time in Chinese history for public art!"

The reader may wonder how it is possible for the Chinese artists who willingly and almost lovingly created portraits of Mao thirty years ago to switch gears so dramatically and create abstractions derived from Western art or portraits of writers and poets. One may well ask whether these artists are hypocrites. I do not think so. If you read carefully between the lines of many of the artists quoted here and look closely at their works, you will see that society called upon them and their known talents to create symbols. Refusal to comply during certain periods would have meant death or, at the very least, imprisonment. Indeed, several of the artists interviewed did serve time in prison. In many cases, however, their talents kept them alive by making them useful contributors to society. In these photographs and between the lines, one can see the powerful desire

for self-expression that until recently was carefully harnessed and hidden, sometimes under the mattress, or sometimes simply in the handling of texture on clay. The love of making art, of putting one's soul into malleable materials and turning them into life, no matter what the subject, no matter what oppressive regime was in power, no matter how deep the isolation, shines through it all.

Index

Boldface page numbers refer to illustrations